GATORS AND SEMINOLES

A FOOTBALL RIVALRY
FOR THE AGES

GATORS AND SEMINOLES
A FOOTBALL RIVALRY FOR THE AGES

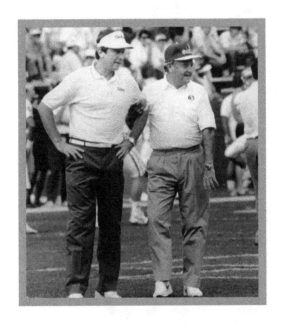

Kevin M. McCarthy

ARCADIA
PUBLISHING

Published by Arcadia Publishing
Charleston, South Carolina

Library of Congress Control Number: 2016947311

For all general information, please contact Arcadia Publishing:
Telephone 843-853-2070
Fax 843-853-0044
E-mail sales@arcadiapublishing.com
For customer service and orders:
Toll-Free 1-888-313-2665

Visit us on the Internet at www.arcadiapublishing.com

*I dedicate this book to the hundreds of players and coaches
involved in the rivalry as well as the thousands and thousands
of fans who have followed the fortunes and misfortunes
of two of this country's finest football teams.*

CONTENTS

ACKNOWLEDGMENTS

Among those I wish to thank in the compilation of this book are my wife, Karelisa Hartigan, for her encouragement and love over the years; our children, Katie, Brendan, Erin, Matt, and Tim, for their interest in my work and their support of the Gators over the years; Prof. James P. Jones of Florida State University for his knowledge of the rivalry and his collaboration 22 years ago on a history of the schools' rivalry; and Carl Van Ness, university historian at the University of Florida, for his help in obtaining good photographs of the games.

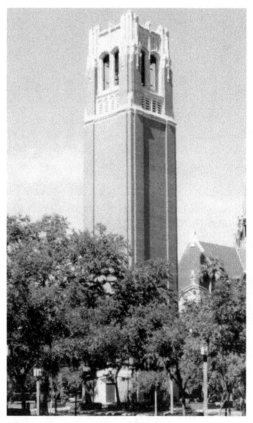

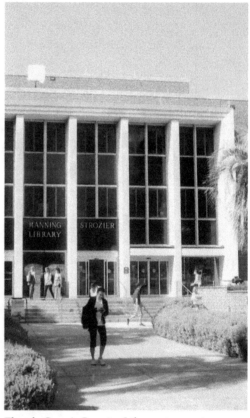

The University of Florida's Century Tower, begun in 1953, commemorates the 100th anniversary of the founding of the school. (Douglas Green.)

Florida State's Strozier Library is a main building on the Tallahassee campus. (WhisperToMe, Wikimedia Commons.)

INTRODUCTION

Two preeminent academic institutions in Florida, the University of Florida (UF) in Gainesville and Florida State University (FSU) in Tallahassee, have competed academically since the 1850s to attract the best students and professors to their campuses. But they have also cooperated in several technical academic endeavors, for example in a low-temperature lab and many scientific experiments. The reasoning behind such cooperation was that, while each school had experts in different fields, those experts could achieve more important results and win more grants if they joined forces and shared results from their labs and experiments.

That cooperation, however, does not extend to sports. Both schools have fielded outstanding teams in football, baseball, and basketball, while consistently vying for first place in their respective athletic conferences, the Southeastern Conference (SEC) for UF and the Atlantic Coast Conference (ACC) for FSU. The two schools, in fact, often compete to attract the same highly skilled athletes from around Florida and the whole nation. Thus, high school teammates may find themselves competing against each other at the college level and then may join forces again at the professional level. Or former high school competitors may find themselves on the same college team and have to forget previous bad feelings toward the other.

As in other universities in the South, football is very important to UF and FSU students, student-athletes, and alumni. The fact that each school has won the national championship in college football three times and each has had three Heisman Trophy winners shows how highly skilled the teams have consistently been over the years and how similar the two teams have been. The equally high caliber of play by both teams in the last 25 years led to their playing each other twice in two seasons (1994 and 1996), both times in the Sugar Bowl after the regular season. One of those postseason games (January 2, 1997) was for the national championship. And the fact that both schools have been able to attract the best coaches, especially in the past two decades, testifies to the high level of remuneration, excellence of facilities, and prestige that coaching at these schools has reached.

Alumni can feel great pride at the accomplishments their schools' athletic teams achieve, and many administrators believe that highly successful and visible teams at the national level will increase student applications to their schools and lead to more generous donations from alumni. The fact that the annual match is played as the last game in the regular season often has huge ramifications on whether one or the other team will play for the national championship or at least be invited to play in a major postseason bowl game.

What the two teams are vying for when they play each other are bragging rights for another year, an edge in the recruiting wars for high school athletes, and an easier time for the coaches on the spring banquet circuit. Years ago, the two teams competed for something called the Makala Trophy, given to the winner of the UF-FSU game by the St. Petersburg Exchange Club. Legend has it that the four-foot-long wood carving of an alligator fighting an Indian warrior named Makala was found a long time ago in Big Cypress Swamp in South Florida. According to the story, the Native American succeeded in beating the gator, thus ridding the land of an oversupply of dangerous gators. But, in doing so, Makala lost his life to the reptile. Each year, his spirit returns

to fight more gators. As in the football rivalry, sometimes the Native American side would win, and sometimes the gators would win. The St. Petersburg Exchange Club would award the trophy each spring to a representative of the winner from the previous fall, and the trophy would remain at that school until it had to change hands. One would hope that this tradition would strengthen and become part of the bragging rights of each year's winner.

In the weeks before the annual slugfest between the Gators and the Seminoles, various jokes circulate in Gainesville and Tallahassee, with the names of the coaches changing according to the man in charge at each school that particular year. For example, during the Spurrier-Bowden era, the following story made the rounds: "Last spring, Steve Spurrier and Bobby Bowden were spending a quiet afternoon fishing for bass on the St. Johns River. While they were looking for just the right spot in the river, a squall suddenly came up and capsized the boat. Bowden maintained his composure and managed to pull Spurrier to safety on the shore. 'Bobby,' a shaken Spurrier mumbled. 'Please don't tell the Gator alumni that I can't really walk on water.' 'Okay,' Bowden replied. 'But only if you promise not to tell the Seminoles that I saved you.'"

Some games are still argued about years later; for example, Gator fans know not to mention Lane Fenner to a Seminole fan. For those not in the know, read about the 1966 game in the pages that follow. Seminole fans know not to talk about the beauty of the early Doak Campbell Stadium unless they want to hear disparaging words about how it resembled a giant erector set.

Whether your favorite cheer is "Scalp 'em" or "Go Gators," you are bound to find out some facts about the rivalry that will amaze, surprise, or disappoint you. This book may not reunite families whose divided loyalties keep them rooting for different teams for one weekend a year, but it may settle arguments or bets on the scores, the players, and the games. Above all, it may clearly show what a consistently high level of play the two teams have reached after struggling in the early years of their history.

1

P RE - 1 9 5 8

The Florida Agricultural College (FAC) in Lake City, Florida, was a predecessor of the University of Florida. Before moving to Gainesville in 1906, FAC had a football team, which played other teams in the state, including Stetson University. The 1907 UF team is shown here. (UF Archives.)

The UF team slowly improved until its eighth coach, Charles Bachman, took over in 1928 for five seasons, compiling a 27-18-3 record. The 1928 team led the nation in scoring, compiled an 8-1 record, lost only one game (to Tennessee on a soggy field in Knoxville), and had the school's first All-American, end Dale Van Sickel, pictured here. (UF Archives.)

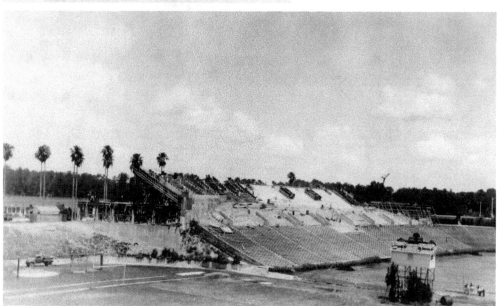

UF officials had a stadium built on the campus in 1930, as seen here. Florida Field hosted its first game, a 20-0 loss to Alabama on November 8, 1930, before a sell-out crowd of 21,769. As the team slowly improved over the years, officials kept expanding Florida Field until 2016, when its max capacity hit 88,000 fans. (UF Archives.)

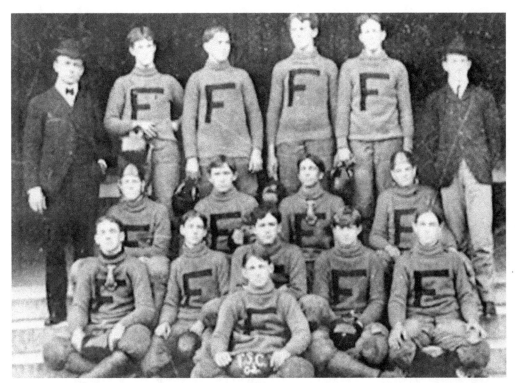

Florida State College, a predecessor of Tallahassee's Florida State University, had a varsity football team for a few years (1902–1904) before the school became the all-women Florida Female College (1905) and the Florida State College for Women (1909). Here is the 1903 Florida State College team. (State Archives of Florida, Florida Memory.)

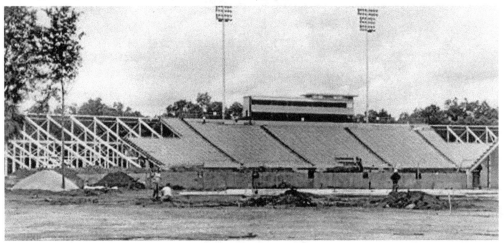

In 1947, the Florida legislature created Florida State University (FSU) from the Florida State College for Women and made it coeducational, just as it did with the University of Florida in Gainesville. Soon after, FSU officials established a varsity football team, which did very well in its first years, going 7-1-0 in 1948. The school built Doak Campbell Stadium in 1950. (State Archives of Florida, Florida Memory.)

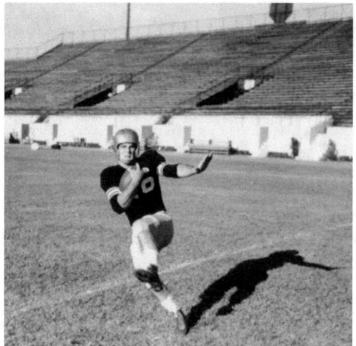

The school's football program recruited players from throughout Florida, including Burt Reynolds out of Palm Beach High School. FSU gave him a football scholarship in 1954, but a serious car accident ended his football career. He did, however, become a strong advocate of FSU and hosted part of *The Bobby Bowden Show*. (State Archives of Florida, Florida Memory.)

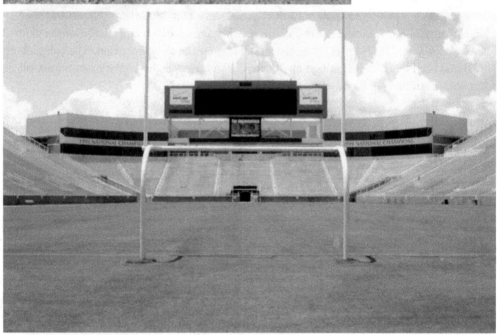

FSU alumni lobbied for a game with UF's Gators, but the latter at first refused. When legislators threatened to require the two teams to play a match, both schools agreed to a first game in 1958, but UF insisted that the games be played in Gainesville until FSU improved its stadium. Little could anyone know that the FSU stadium would eventually look like this. (UkrNole 485, Wikimedia Commons.)

1950s — 1960s

The program for the initial game was the first of many in what would turn out to be a long, bitterly fought rivalry. 43,000 fans turned out for the first game. UF insisted that the first six games of the rivalry be played at Florida Field in Gainesville because of what UF officials considered "inadequate" facilities at FSU. UF won this 1958 game over FSU with a score of 21-7. (UF Sports Information.)

F.S.U. vs Florida
November 22, 1958
Price **50c**

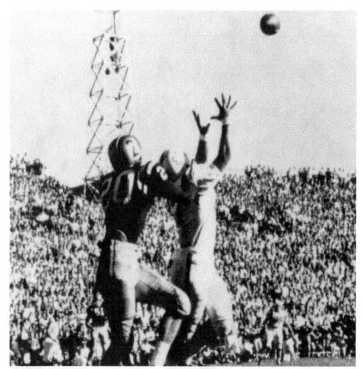

In that first game, FSU led in yards gained, 286 (97 rushing, 189 passing), against UF, 238 (219 rushing, 19 passing), but the difference in the game was FSU's mistakes, which were three fumbles and two interceptions, all of which led to Gator scores or stopped promising Seminole drives. One of the interceptions was by UF's Dave Hudson, who picked off an FSU pass intended for Bobby Renn. (UF Archives.)

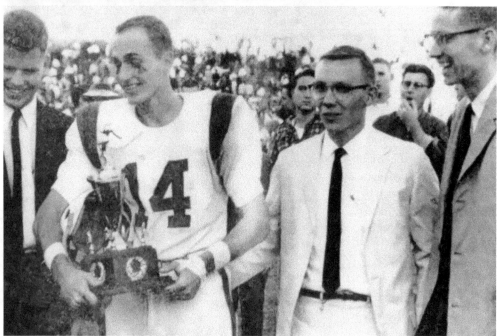

UF's junior-class officers presented UF quarterback Jimmy Dunn (No. 14) with the MVP trophy. Dunn, who almost went to FSU, ran for two touchdowns in that first game. The Gators went on to a disappointing 6-4-1 season, including a loss to Mississippi in the Gator Bowl. The Seminoles had a 7-4 season, including a loss to Oklahoma State in the Bluegrass Bowl. (UF Archives.)

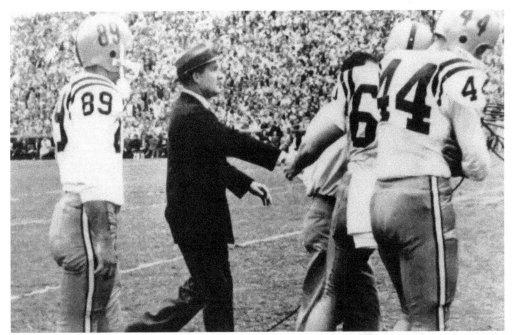

In 1959, UF won against FSU with a score of 18-8. FSU coach Perry Moss, seen here shaking hands with his players, replaced Tom Nugent but announced before the UF game that he would be leaving after only one year of coaching to become coach and general manager of the Montreal Alouettes of the Canadian Football League. (UF Archives.)

UF head coach Bob Woodruff, seen here with some of his players in the late 1950s, resigned at the end of the 1959 season after 10 years as head coach (1950–1959) with a mediocre record of 53-42-6. Many Gator fans considered him just too conservative a coach and wanted a head coach who would take the team to the next level. (UF Archives.)

A handshake before the annual game was indicative of the generally good relations between the players of the two teams in the early years. As time went on, however, the competitive feelings between the two teams increased dramatically, especially when the outcome of the game would help determine the national title hopes of one of the teams. (UF Archives.)

The second game, which was played under an overcast sky in Gainesville, resulted in an 18-8 Gator victory in a season that saw UF finish with a 5-4-1 record and FSU with a 4-6 record. Some good news right before the game was FSU's announcement that Vaughn Mancha would be the school's new athletic director. (State Archives of Florida, Florida Memory, photographer Ellis Finch.)

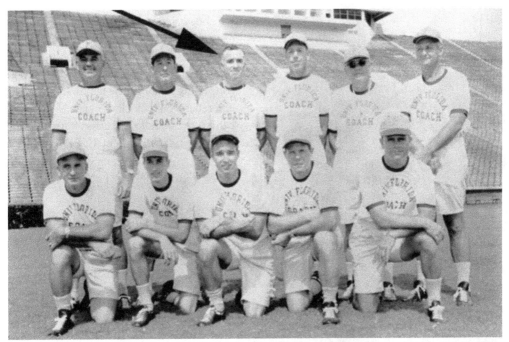

The 1960 game was a close one, with 3-0 as the final score; UF won. Both schools hired new head football coaches in 1960. Ray Graves (second row, third from left) took over for the Gators after playing professional football for two years and coaching at Georgia Tech for 13 years. Graves became one of the most popular coaches at UF and had great success in recruiting several outstanding quarterbacks. (UF Digital Collection.)

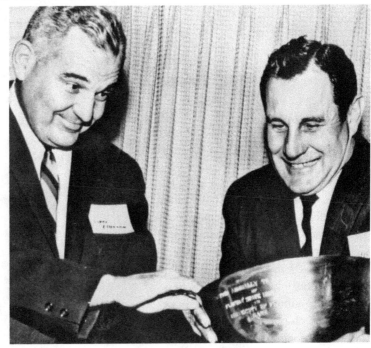

FSU hired Bill Peterson, seen here at right with UF assistant coach Gene Ellenson looking at the Florida Cup, which was awarded to the winner of the round-robin among UF, FSU, and the University of Miami each year. Peterson coached FSU for 11 years, compiling a 62-42-11 record, before leaving to coach the Owls of Rice University. (State Archives of Florida, Florida Memory.)

UF cheerleaders found a good use for their megaphones at the rainy 1960 game. The umbrellas seen in the background would be outlawed in later years due to fans concealing liquor in the handles. Plus, the umbrellas would block the view of those behind them and could cause water to drip on those in front of them. (UF Archives.)

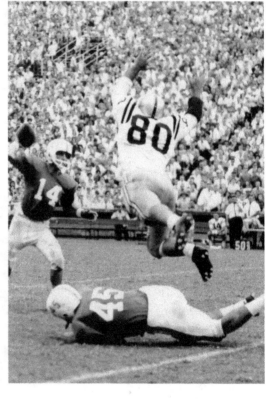

UF quarterback Larry Libertore (No. 14) attempts a pass while FSU's Tony Romeo (No. 80) leaps over Don Goodman (No. 45). The game was expected to be a high-scoring, passing duel, but turned out to be a 3-0 win for UF—with a field goal being the only score. The closeness of that third annual match between the two schools pointed out how equal they were becoming. (UF Archives.)

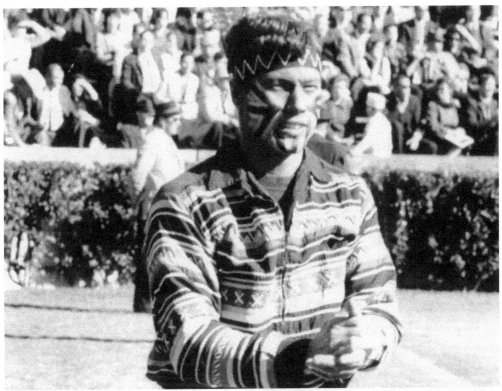

The 1961 game was a 3-3 tie. The FSU mascot, a young man dressed as a Seminole Indian (above), and the UF mascot, a young man outfitted with a Gator head and tail (right), would evolve in the early 1960s into Chief Osceola on his horse, Renegade, and a "scarier" Gator. FSU would be subject to pressure from those who did not approve of using a Native American for a mascot, arguing that it was demeaning to Native Americans. The Gator would eventually become Albert and would be joined by the female Alberta. Having a gator for a mascot led to the nicknaming of the UF stadium as "the Swamp." The stadium was officially named Ben Hill Griffin Stadium. (Both, UF Archives.)

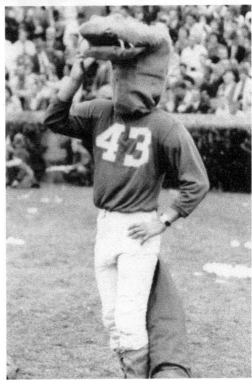

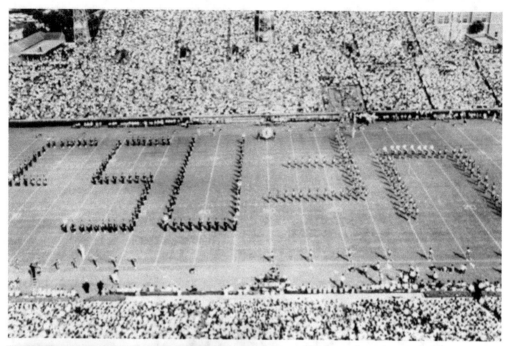

The marching bands from each school appeared on Florida Field at the same time at the 1961 game to spell out the initials of their schools. In time, the bands would get larger and perform by themselves at halftime of the annual game. The bands would also often go to away games to provide entertainment to the fans. (UF Archives.)

In 1961, before FSU coach Bill Peterson and UF coach Ray Graves (pictured) got their offenses into high gear, the two teams played to their first tie, which Coach Graves likened to a "death in the family." The final score, 3-3, indicated how hard a fight the games were becoming and also how equal the talent was on each team. (UF Archives.)

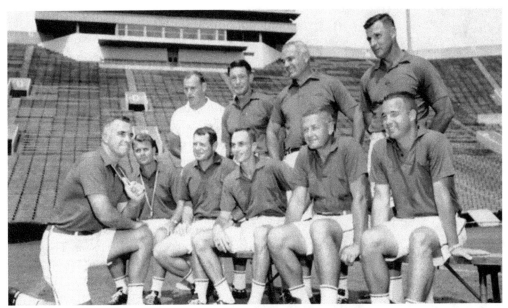

UF trounced FSU in 1962 by 20-7. The head coaches at each school put together a coaching staff that went along with the coaching philosophy of each head coach. Here, UF head coach Ray Graves (left) and his assistants pose at the stadium on Florida Field. Graves compiled an impressive record of 70-31-4 in his 10 years at UF (1960–1969). (UF Digital Collection.)

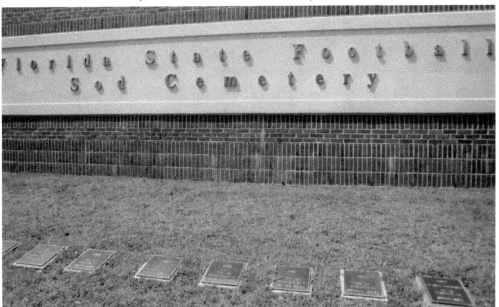

In 1962, FSU coach Bill Peterson brought back a piece of sod from the site of a particularly hard-fought, unexpected victory over a favored foe and buried it near the FSU practice field. From then on, the football captains brought back a piece of sod from FSU away games and other such hard victories and "buried" it in what became known as the "Sod Cemetery." (UkrNole 485, Wikimedia Commons.)

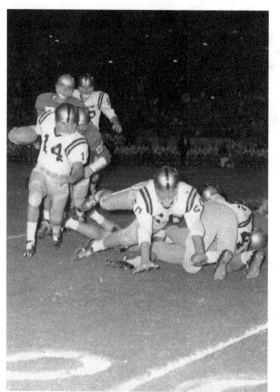

One of FSU's multi-threats was quarterback Eddie Feely (No. 14), shown here in the 1961 game against Georgia. By the time he graduated in 1962, he had set FSU career records in completions (160), passing yardage (1,711), and total offense (2,346 yards). (State Archives of Florida, Florida Memory, photographer Emmette Jackson.)

FSU's cheerleaders are skilled athletes able to rouse Seminole fans into loud, vocal support for their teams. The cheerleading squads evolved into two teams, one being all female and the other coed. Both teams led the cheers at all FSU home football games. Travel teams were selected from both teams. The members of the teams also performed at community service events. (State Archives of Florida, Florida Memory.)

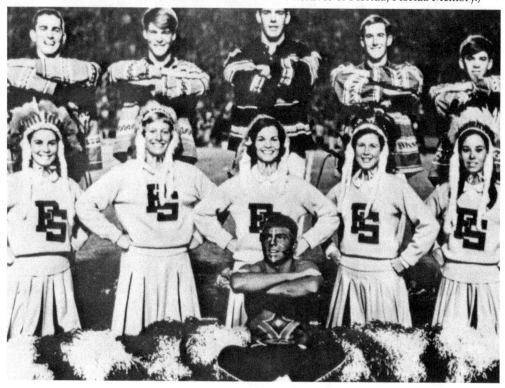

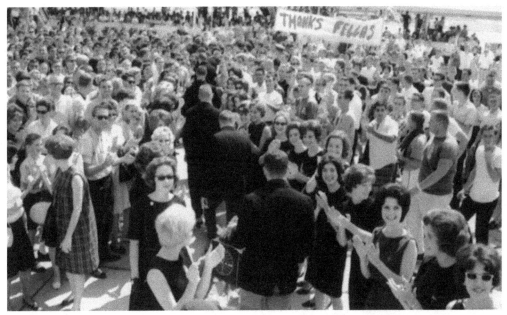

In 1963, UF had another victory against FSU, 7-0. Whenever FSU football players returned home after beating a formidable foe like highly ranked Miami in 1963, as shown here, fans would meet them at the airport and urge them to beat their upcoming opponents, like the Gators, but that would not happen in 1963. (State Archives of Florida, Florida Memory.)

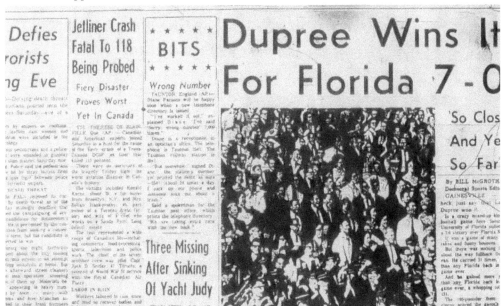

The Tallahassee newspaper summed up the 1963 game with the headline "Dupree Wins It For Florida 7-0." Gator fullback Larry Dupree, a junior who would become an All-American the next year, rushed for 131 yards. His 31 carries broke the Gator record of 29 that Rick Casares set in 1952. (*Tallahassee Democrat.*)

When the Seminoles wrapped up their spring practice session, those players who excelled would receive awards at the annual Garnet and Gold game. In the 1963 game, Burt Reynolds (second from left) was one of those giving the awards. Reynolds, whose FSU football career was cut short by an injury, was a strong supporter of the school's athletic programs. (State Archives of Florida, Florida Memory.)

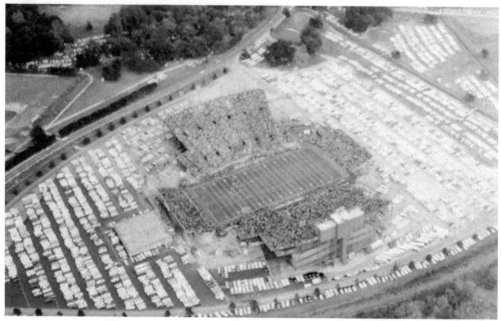

1963 would be the last year in which the annual game was held only in Gainesville. This aerial view of Doak Campbell Stadium from around that time shows that FSU had made its stadium larger and more accommodating for the annual contest. (State Archives of Florida, Florida Memory, photographer Karl E. Holland.)

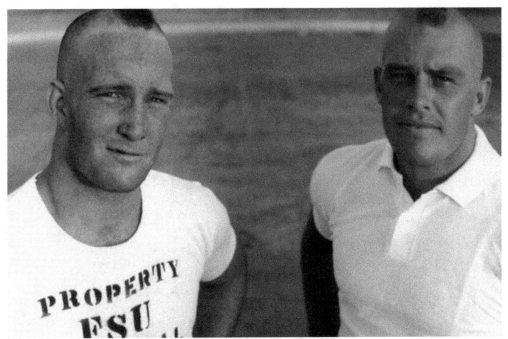

Finally, in 1964, FSU won against UF, 16-7. That same year, the annual game moved to Tallahassee after FSU increased its stadium capacity to 43,000. The Gators, ranked first nationally in pass defense, could not stop the passing combo of FSU quarterback Steve Tensi and receiver Fred Biletnikoff. Biletnikoff and tight end Red Dawson (seen here on the left with Avery Sumner) were cocaptains of the Seminoles. (State Archives of Florida, Florida Memory.)

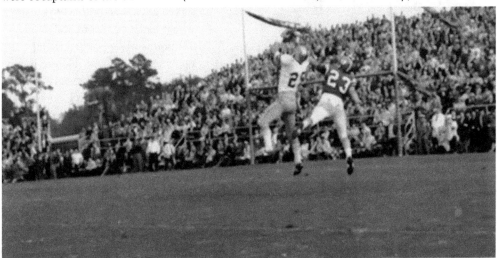

FSU's receiver Fred Biletnikoff (No. 25), seen here catching a pass in the UF game in Tallahassee, would become the Seminoles' first All-American. He then went on to play professional football for 14 seasons with the Oakland Raiders and was inducted into both the College Football Hall of Fame and the Professional Football Hall of Fame. (State Archives of Florida, Florida Memory, photographer Ellis Finch.)

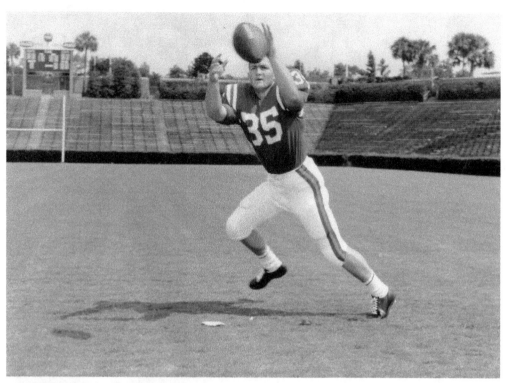

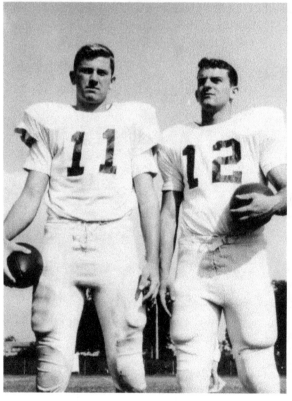

Larry Dupree (No. 35), the first Gator running back to earn first-team All-American honors (1964), served as captain of the 1964 team, which had a 7-3 record and scored 181 points while holding their opponents to only 98. Dupree was the first UF player to receive first-team All-Southeastern Conference honors three times. (UF Archives.)

UF sophomore Steve Spurrier (No. 11) and senior Tommy Shannon (No. 12) shared quarterbacking duties in 1964, a year when the Seminoles won their first match in the UF-FSU rivalry, 16-7. FSU went to the Gator Bowl in the team's first major postseason bowl, defeated Oklahoma 36-19, and finished the season with a remarkable 9-1-1 record, its best record in 18 years of football. (UF Digital Collection.)

In 1965, UF won against FSU, 30-17. As so often happened among the players in this rivalry, some of them went on to great achievements after graduation. For example, T.K. Wetherell, who played for the Seminole football team from 1964 to 1967 and whose statue is in front of the Westcott Building at FSU, later served as president of the school from 2003 through 2009. (Ayzmo, Wikimedia Commons.)

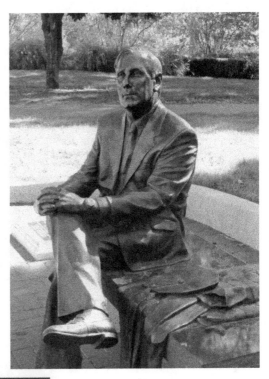

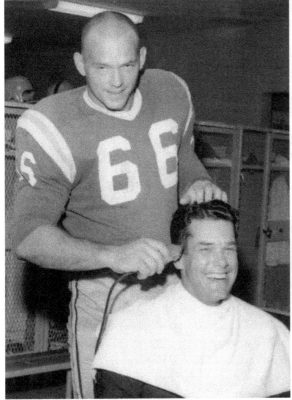

In 1965, an FSU player cuts the hair of Don James, defensive coach for the Seminoles (1959–1965). James later became head coach at Kent State University and the University of Washington. Many assistant coaches for both the Gators and Seminoles later became head coaches. (State Archives of Florida, Florida Memory.)

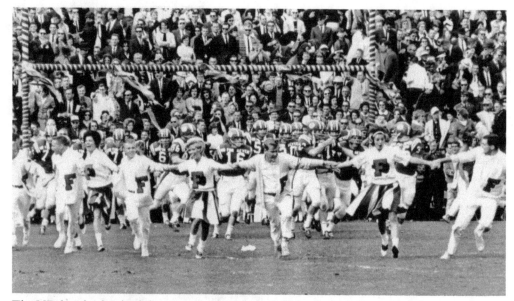

The UF cheerleaders lead the Gators onto Florida Field for the eighth match-up between the two bitter rivals. Over 49,000 fans attended the game. UF quarterback Spurrier threw the winning touchdown pass to Gator wide receiver Charley Casey, a pass that Spurrier later called his favorite completion over his whole UF career. (UF Archives.)

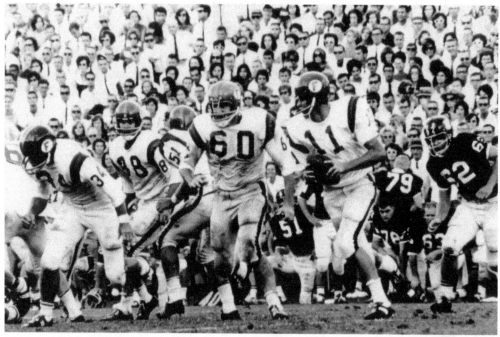

UF quarterback Steve Spurrier (No. 11), pictured with the football during the FSU game at Florida Field in Gainesville, was credited with 316 total yards in the Gator victory. Later, he led his 6-3 team to a victory over Missouri in the Sugar Bowl, the first UF team to play in a major bowl out of state. (State Archives of Florida, Florida Memory, photographer Ellis Finch.)

The 1966 game's final score was 22-19, UF. The game in Tallahassee is still argued about today because of the play seen here—did FSU receiver Lane Fenner score the game-winning touchdown or did he lose control of the ball as he rolled out of bounds? Photographs displayed throughout Tallahassee store windows the next week seemed to show Fenner in bounds, but the referee called him out of bounds. (State Archives of Florida, Florida Memory.)

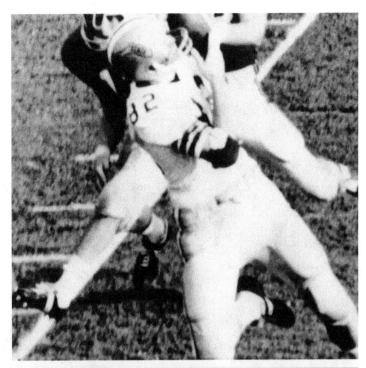

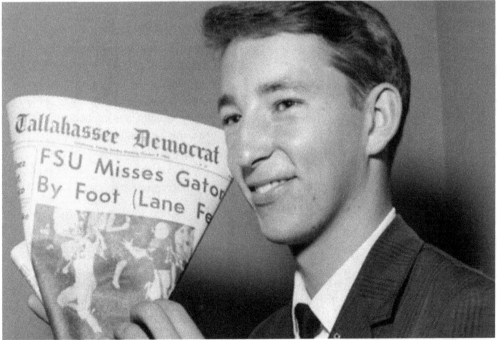

An FSU football fan holds up the *Tallahassee Democrat* with the photograph of Lane Fenner catching or not catching the ball. The Gators held on for a 22-19 win, one that is still argued about today in Tallahassee. A crowd of 46,798, the largest to see FSU play at home in their 26-year football history, saw the game at Campbell Stadium. (State Archives of Florida, Florida Memory.)

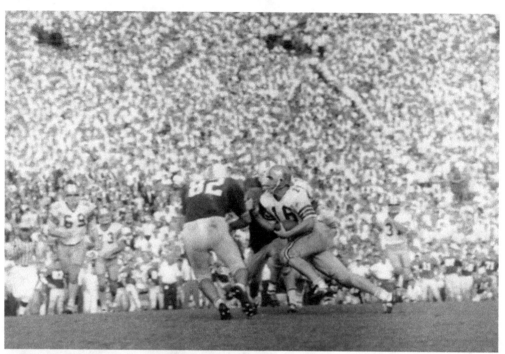

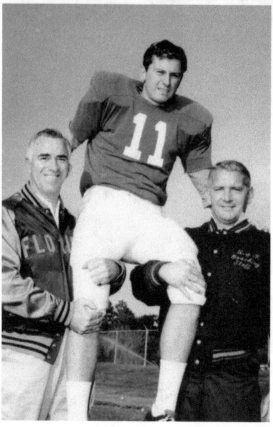

FSU quarterback Gary Pajcic (No. 16), pictured running with the football during the UF game in Tallahassee, made his first appearance in the intrastate classic and played well, completing 18 of 32 passes for 208 yards. It was Pajcic who threw what many thought was a touchdown pass to Lane Fenner, before linesman Doug Moseley nullified the play. (State Archives of Florida, Florida Memory, photographer Ellis Finch.)

UF quarterback Steve Spurrier, seen here with two of his coaches, won the 1966 Heisman Trophy, awarded annually to the most outstanding player in college football. He became the first Heisman Trophy winner to coach another such winner, Danny Wuerffel, also of UF, in 1996. Spurrier was the first winner to donate his trophy to the university president so that UF students and faculty could "share" the award. (UF Archives.)

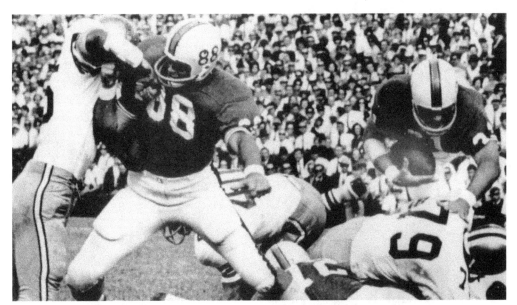

In 1967, FSU defeated UF, 21-16. Still annoyed at the previous year's infamous "Lane Fenner game," FSU fans went to the Florida Field showdown with badges that read, "Forget? Hell no!" Here, UF's Jim Yarbrough (No. 88) blocks for runner Tom Christian, who scored one of the touchdowns for the Gators, but it was not enough to prevent the first win by the Seminoles in Gainesville. (UF Archives.)

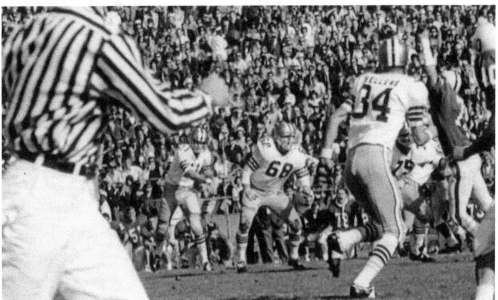

FSU quarterback Kim Hammond, who was injured in the first half, returned in the second half of the 1967 game and threw the winning touchdown to Ron Sellers, who finished with seven catches for 153 yards. For his efforts, Hammond was named the AP back of the week. The passing combination of Hammond to Sellers, pictured here in another game that season, was long remembered by Seminole fans. (State Archives of Florida, Florida Memory.)

FSU head coach Bill Peterson addresses the Seminole Boosters during a Tallahassee luncheon. Coach "Pete" recruited the Seminoles' first black football players, including J.T. Thomas, the first black varsity football player at FSU. Thomas was drafted by the Pittsburgh Steelers in 1973 and played for the Steelers and the Denver Broncos. (State Archives of Florida, Florida Memory, photographer Dan Stainer.)

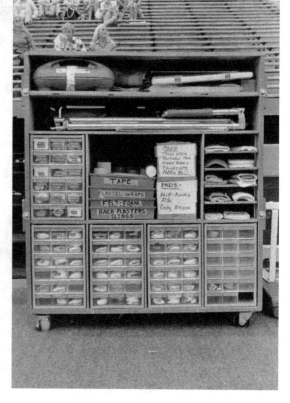

The equipment box on each sideline during the annual rivalry game had to be stocked with tape and lotions and salves for the expected injuries from the hard-fought games. Medical doctors attended each game to care for injured players and to advise the coaches about the status of those who were hurt. (UF Information Services, Herb Press.)

In 1968, UF bested FSU 9-3. The card section at FSU's Campbell Stadium used color-coordinated signs to spell out "FSU." The student sections of UF's and FSU's stadia usually had the signs to display during the games and were often much rowdier than the alumni sections, which were also more protected from the direct sun. (State Archives of Florida, Florida Memory.)

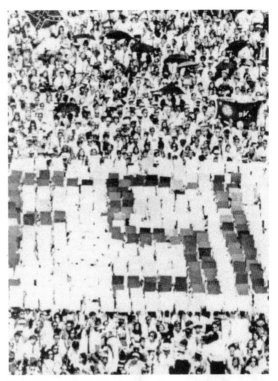

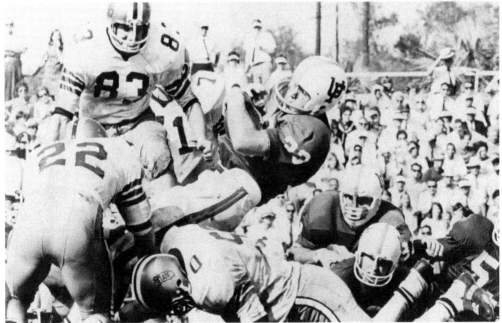

In the 1968 game, UF's All-American fullback Larry Smith (No. 33) is gang-tackled by a ferocious FSU defense, including Chuck Eason (No. 22), Ron Wallace (No. 83), and Harry Zion (No. 7). Over 45,000 fans went to Doak Campbell Stadium that day to watch two highly explosive offenses meet two determined defenses—ending in a 9-3 victory for the Gators. (UF Archives.)

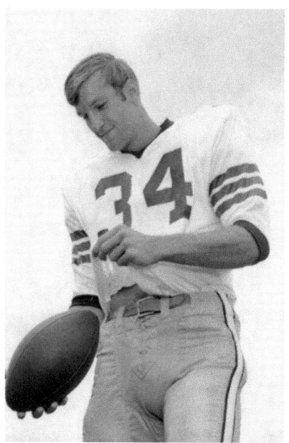

One great receiver for FSU from 1966 through 1968 was Ron Sellers, a two-time All-American (1967, 1968) who went on to hold FSU career records for receptions, receiving yards, and most 200-yard games. He later played professional football for the Boston Patriots of both the American Football League and the National Football League (NFL) and for the Dallas Cowboys and Miami Dolphins of the NFL. (State Archives of Florida, Florida Memory.)

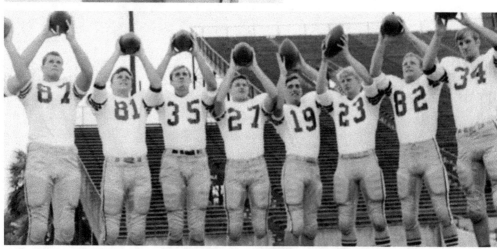

The 1968 UF victory began the longest winning streak for either team against the other—nine wins in a row. These FSU football players pose for a photograph at Campbell Stadium that year. From left to right are Bill Rimby (No. 87), Jim Tyson (No. 81), Mike Gray (No. 35), Billy Cox (No. 27), Phil Abraira (No. 19), Don Pederson (No. 23), Rhett Dawson (No. 82), and Ron Sellers (No. 34). (State Archives of Florida, Florida Memory.)

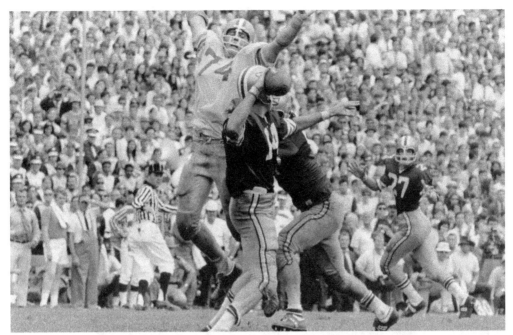

Some 64,000 fans in Gainesville watched sophomores John Reaves and receiver Carlos Alvarez set many records for the Gators and beat the Seminoles in 1969, 21-6. The defense was also strong, as evidenced by the constant harassment of Seminole quarterback Bill Cappleman (No. 14) trying to hit an open Arthur Munroe (No. 27) while UF's Jack Youngblood (No. 74) leaps high. (UF Information Services.)

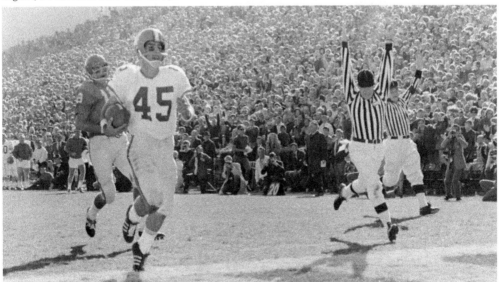

Carlos Alvarez (No. 45) set many receiving records for the Gators. Among the Gator records he still holds are most pass receptions in a single game (15) and in a single season (88) and career receiving yards (2,563). He went on to become a practicing attorney in Tallahassee, one of the cities in which he did so well on the football field. (UF Information Service.)

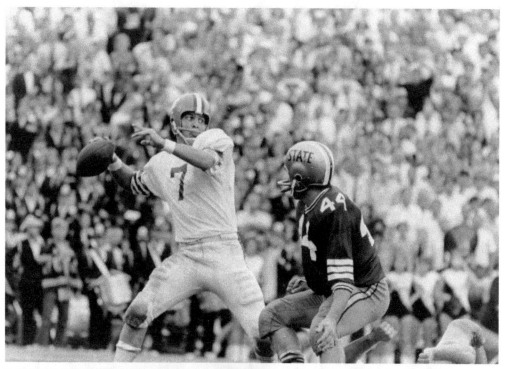

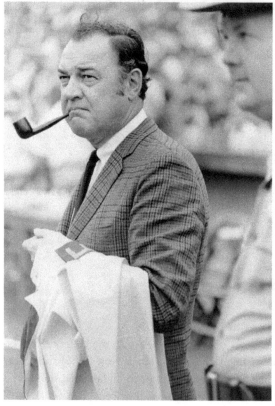

UF quarterback John Reaves (No. 7) became a first-team All-American in 1971 and finished his career with the Gators as the all-time leading passer in the SEC and National Collegiate Athletic Association (NCAA) with 7,581 yards. He went on to a professional career; he played quarterback in the NFL for 11 seasons and in the United States Football League (USFL) for three seasons in the 1970s and 1980s. (UF Archives.)

Governor Claude Kirk, shown here in 1969, like many state officials, would try to be neutral during the annual Gator-Seminole football clash, especially since the two teams had thousands of fans throughout the state. The governors would sometimes sit on one side for the first half and then on the other side during the second half—so as to show no partiality. (UF Archives.)

1970S

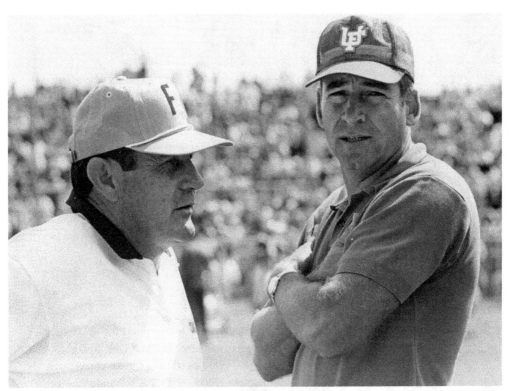

The 1970 game score was 38-27; UF won. After the 1969 regular season, UF hired Doug Dickey, the former Gator quarterback and then-coach of Tennessee, to be the new head coach. In his nine seasons as the Florida coach (1970–1978), Dickey had an overall record of 58-43-2. FSU's Coach Peterson (on the left) and Coach Dickey seemed to have a good relationship. (UF Information Services.)

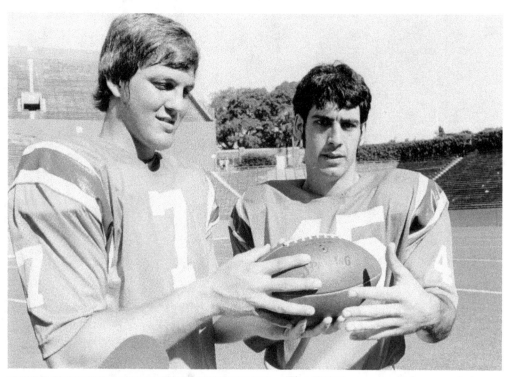

The 42,700 spectators who attended the annual slugfest in Tallahassee saw a new record for points scored by both teams in the series (65) and the most points by the losing team (27). Gator quarterback John Reaves (left) and receiver Carlos Alvarez continued to do well. Reaves threw for 244 yards and two touchdowns, leading the Gators to the 38-27 victory. (UF Information Services.)

One of the seniors on the UF squad was defensive end Jack Youngblood, who lettered at UF for three years (1968–1970). He was inducted into the College Football Hall of Fame and starred with the Los Angeles Rams (1971–1984). In 1970, both FSU and UF finished with respectable 7-4 records. (UF News & Public Affairs.)

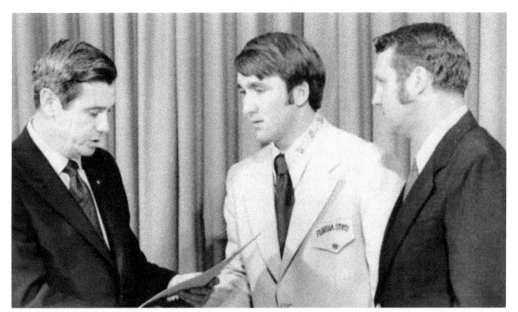

With a close score of 17-15, UF won the 1971 game. Governor Reubin Askew (left) reads a resolution honoring Florida State University quarterback Gary Huff (center) as the nation's No. 1 passer while FSU coach Larry Jones (right) looks on. Huff was one of many FSU quarterbacks who excelled at the position. Three quaterbacks would go on to win the prestigious Heisman Trophy. (State Archives of Florida, Florida Memory.)

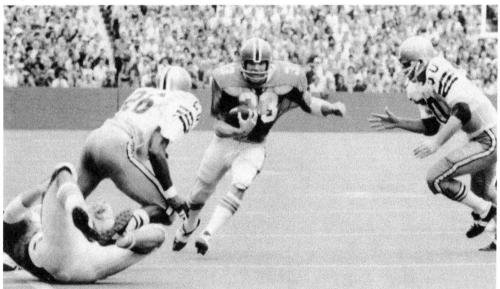

In 1971, the Seminoles, unbeaten at 5-0 and ranked 16th in the country, traveled to Gainesville to play the Gators, winless at 0-5. Few among the 65,109 fans there expected an upset. FSU's Gary Huff seemed ready to trounce the Gators, but the latter had Tommy Durrance (No. 33), seen here trying to evade FSU's James Thomas (No. 26). Amazingly, the Gators beat the Seminoles 17-15. (UF Information Services.)

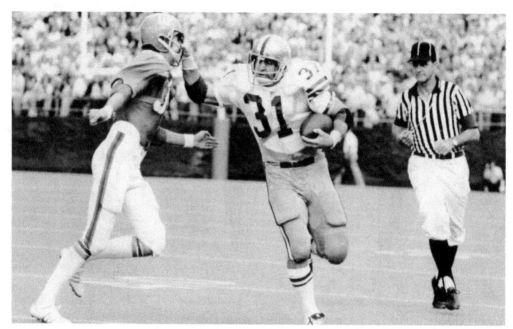

FSU's Paul Magalski (No. 31), seen here stiff-arming a UF defender in the game, helped the Seminoles amass an impressive 350 total yards compared to only 196 for the Gators. The difference was the fact that the Seminoles had four fumbles and an intercepted pass, while the Gators had no turnovers. (UF Information Services.)

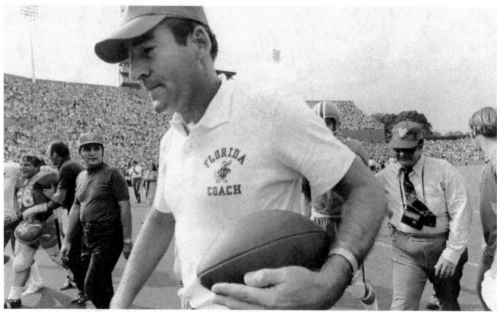

Gator head coach Doug Dickey probably felt that his team "stole" a victory that year over FSU, but he was happy to take it. He had the Gators, who usually relied on the strong passing of John Reaves, instead go to the running game and a tenacious defense. UF's 54 rushing plays ate up the clock and kept FSU's quarterback Huff off the field. (UF Information Services.)

The Gators blasted the Seminoles out of the water in the 1972 game; the final score was 42-13. UF head coach Doug Dickey (left) and FSU head coach Larry Jones (right) appeared at a joint press conference in 1972 with nine-year-old Susan Assad of Tallahassee for the benefit of the Florida Special Olympics. Despite their cordiality off the field, the two head coaches were fierce competitors on the gridiron. (State Archives of Florida, Florida Memory.)

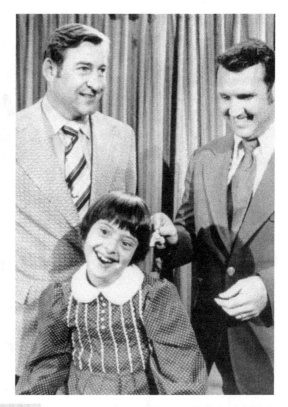

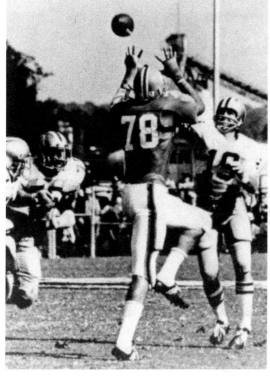

When the Gators went to Tallahassee for their annual slugfest with the Seminoles, the latter were 14-point favorites because of their record up to that point (4-0), their national ranking (11th), home-field advantage for only the fifth time, and outstanding quarterback Gary Huff (No. 19), pictured here in the game throwing over UF's Clint Griffith (No. 78). (UF Archives.)

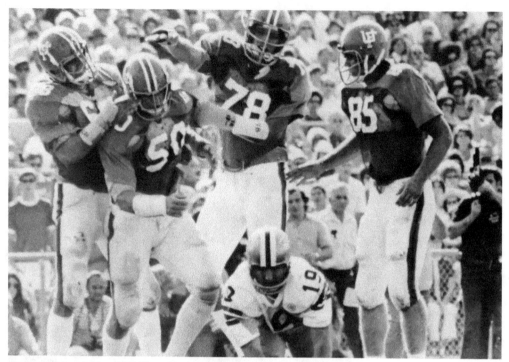

But even the skills of Huff could not overcome the nine turnovers by the Noles in the first 11 times they had the ball. The result, UF 42 to FSU 13, was the largest score and the most lopsided in the 15 games played thus far in the series. (UF Archives.)

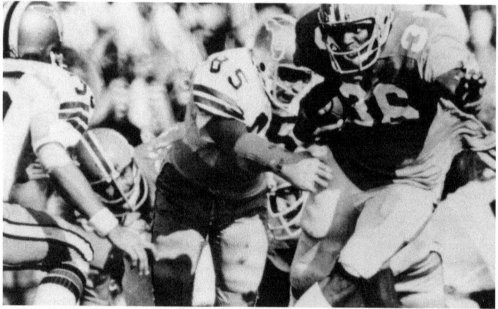

UF's Lenny Lucas (No. 36) runs while FSU's Earl Passwaters (No. 85) and Randy Shively (No. 35) close in. Among the series records set in that game were most passing yards (341, FSU), most total offense (463, FSU), and most points by one team (42, UF). (UF Archives.)

In 1973, UF shut out FSU, 49-0. On hand at the annual game in Gainesville was James A. Van Fleet, UF head coach (1923–1924) and commanding general of US Army and other United Nations forces during the Korean War. Van Fleet's two-season record of 12-3-4 had one of the best winning percentages of any UF coach, which was .800. (Wikimedia Commons.)

FSU had a poor record (0-10) and had scored only 13 touchdowns that season. The Gators had a 6-4 record up to that point but had won their six games by a total of just 26 points. That day, however, they cruised to a 49-0 win. UF officials kept expanding the stadium, pictured here in 1956, as the team kept improving. (State Archives of Florida, Florida Memory.)

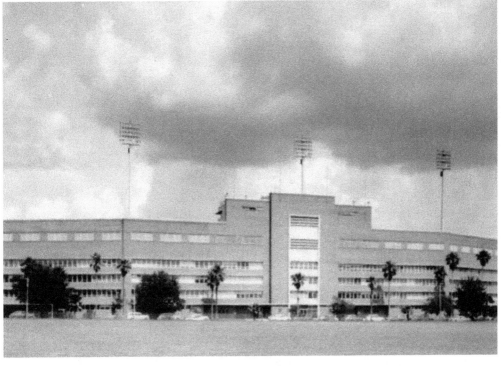

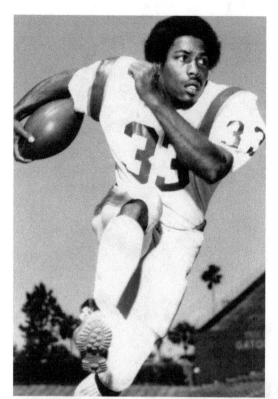

UF runner Nat Moore, who had broken his leg earlier in the season against Alabama, still managed to gain 109 yards against the Seminoles in the 1973 game. After the end of the game, when previous matches had had fist fights, both teams met in the middle of the field to offer congratulations or sympathy and then filed out together through the single gate leading to the dressing rooms. (UF Sports Information.)

Meanwhile in Tallahassee, Doak Campbell Stadium was being expanded as the Seminoles attracted more and more fans, but FSU's coach Larry Jones would not see the stadium after the humiliating loss and a three-year record of 15-19. Gator coach Doug Dickey, on the other hand, had guided his teams to four straight wins against the Seminoles, a rare feat. (State Archives of Florida, Florida Memory.)

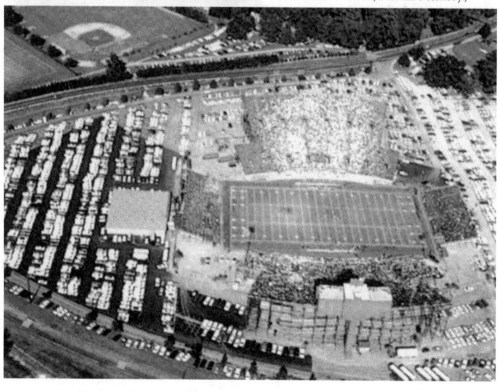

The 1974 game score was 24-14, with UF winning. FSU hired a new head football coach, Darrell Mudra, who had turned five losing teams into winners. The Seminoles headed into their annual game with the Gators winless (0-5), while the Gators were 4-1 and ranked 12th in the country. (State Archives of Florida, Florida Memory.)

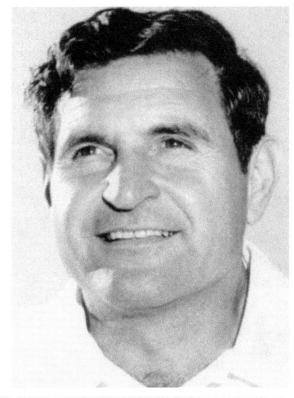

FSU cheerleaders in the early 1970s were spirited and enthusiastic, but their Seminoles were struggling. The largest crowd up to that point (42,541) ever to see a night game at Campbell Stadium in Tallahassee watched the first night game of the UF-FSU series, one that ended in a rather close 24-14 victory for the Gators. (State Archives of Florida, Florida Memory.)

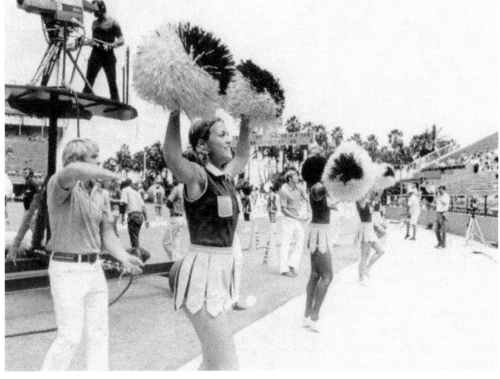

The difference in the game and the one who led the Gators to victory was Don Gaffney, the first African American to start as quarterback at UF. Gaffney played for three years (1973–1975) at UF. In the fourth quarter of the 1974 game, he checked off at the line of scrimmage and called the pass play that led to the winning touchdown. (UF Sports Information.)

One of two All-Americans for the Gators that season was linebacker Ralph Ortega, pictured here; the other was guard Burton Lawless. Ortega had high praise for the 1974 Seminoles, saying that they had "improved 110 percent. That quarterback Jimmy Black played one hell of a game." (UF Sports Information.)

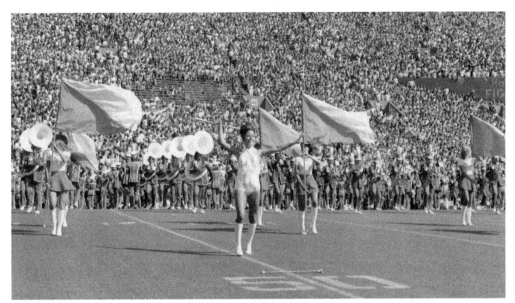

The Seminoles lost in 1975, 34-8. The marching bands of each school usually put on impressive halftime shows during the games, as pictured here with the 1975 marching band of the Gators. The UF Fightin' Gator Marching Band, also known as the Pride of the Sunshine, is the school's official marching band. FSU's official marching band is known as the Marching Chiefs. (UF Information Services, Herb Press.)

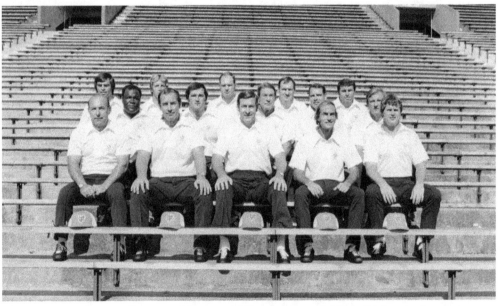

The Gator coaching staff, pictured here in 1975 around coach Doug Dickey in the center, was gelling nicely, whereas the Seminoles were struggling and would fire Darrell Mudra after a disappointing 4-18 record in his two years at FSU. In 1975, UF and FSU began the game with opposite records, 4-1 for the 12th ranked Gators and 1-4 for the Seminoles. (UF Information Services, Herb Press.)

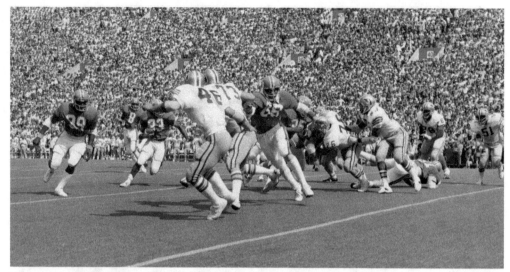

UF's Larry Brinson (No. 39) leads the way for Tony Green (No. 33) against FSU's Lee Nelson (No. 46) and Randy Coffield (No. 73) in the 1975 game, which the Gators won 34-8. The Gators had a strong running game that day and were led by senior fullback Jimmy "Du" DuBose, who rushed for 204 yards on 22 carries. (UF Information Services, Herb Press.)

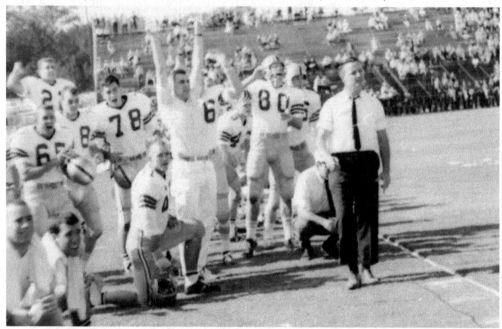

To replace Mudra, FSU hired Bobby Bowden, seen here as the Seminoles' offensive ends' coach in 1964. Bowden had coached at Howard, South Georgia College, again at Howard (which had been renamed Samford), and then at FSU under coach Bill Peterson. After coaching under Peterson, Bowden went on to become offensive coordinator at West Virginia University and then head coach there. He was then rehired on at FSU; his tenure as head coach at FSU (1976–2009) would be extremely successful. (State Archives of Florida, Florida Memory.)

FSU was defeated again in 1976, 33-26. One Gator player that season was Berj Yepremian (No. 1), shown here with Alan Williams (No. 2). Yepremian set Gator records for point-after-touchdown percentage accuracy for a minimum of 50 kicks: 56 of 57. His four field goals in a 1978 game were surpassed once by Brian Clark (five in 1980) and twice by Bobby Raymond (six in both 1983 and 1984). (UF News & Public Affairs.)

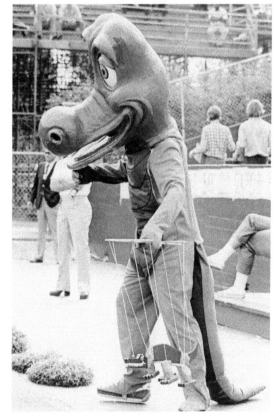

The Gators were experimenting with different Gator mascots, and some of them were not too fierce looking. This particular costume, designed at Walt Disney World for about $5,000, built up temperatures inside the outfit that could reach 120 degrees. The Gator mascot, which does not talk, has to mime a lot. (UF News & Public Affairs, John Woodhead.)

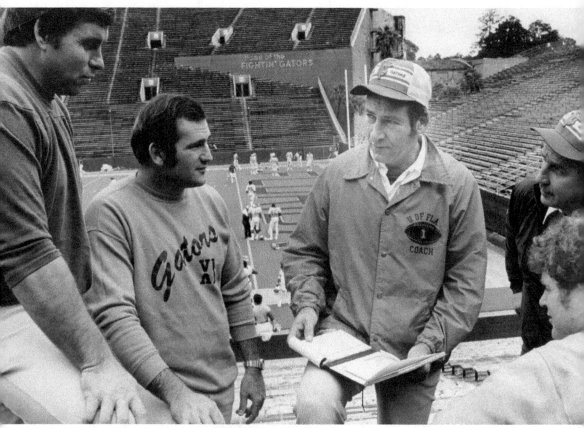

The Gators, under head coach Doug Dickey, seen in the middle of his coaches, produced 417 yards in the 1976 game; many of the yards were on the ground with Willie Wilder and Tony Green. The game, a 33-26 win for the Gators, would be the last win for UF in the rivalry for four years. In that game, the Seminoles amassed 507 total yards and 28 first downs, the latter a new mark for the series. The leader of the Seminoles was quarterback Jimmy Black, who completed 14 of 17 for 211 yards and ran for another 46 yards on the ground. When he went down with an injury, FSU freshman Jimmy Jordan took over but could not lead his team to victory. Jordan played a major role in the rivalry during his career. After the game, Coach Bowden said, "I don't think you can ask for any better effort." (UF Information Services, Herb Press.)

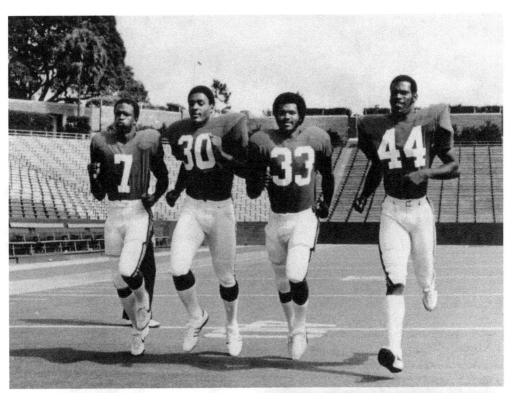

In 1977, the Seminoles' luck turned around, and they won, 37-9. The 1977 Gator backfield consisted of (from left to right) quarterback Terry LeCount, fullback Earl Carr, halfback Tony Green, and halfback Willie Wilder. Coach Bowden of the Seminoles relied on quarterbacks Wally Woodham and Jimmy Jordan and runner Larry Key, who gained 145 yards and became the first FSU player to rush for more than 1,000 yards in a season. (UF News & Public Affairs.)

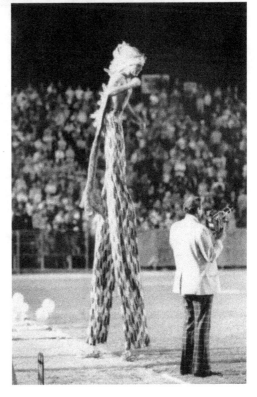

In 1977, the UF-FSU game was moved to the end of the season to become part of "rivalry week." FSU was 8-2 and ranked 19th in the AP poll when they faced the 6-3-1 Gators. That season was the last one that saw FSU use a person dressed as a Native American on stilts for a mascot. (State Archives of Florida, Florida Memory, photographer Bob O'Lary.)

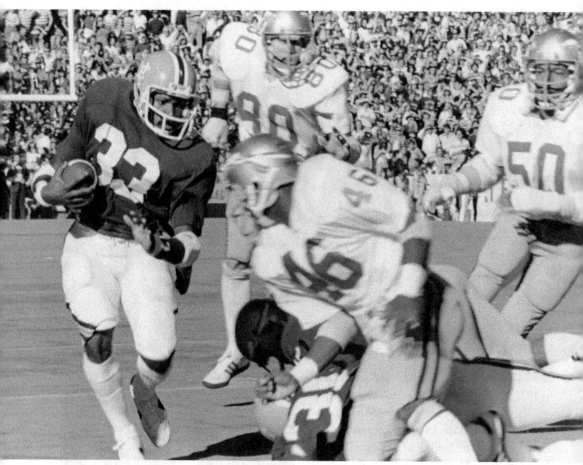

In the 1977 game, FSU's Ivory Joe Hunter (No. 46), Ronald Simmons (No. 50), and Scott Warren (No. 80) close in on UF's Tony Green (No. 33). Simmons, a freshman nose guard, became one of the great names in Seminole football history. Another defensive stalwart was Aaron "A.C." Carter, a Gainesville player who helped lead the FSU defense from 1974 to 1977. The garnet-and-gold defense limited the Gators to just three first-half field goals by Berj Yepremian. The final result, a Seminole victory at 37 to 9, was the first FSU blowout of the Gators and the most points that FSU had scored on UF up to that point. The Seminoles' edge in yardage was 578 to 200, and in first downs, 27 to 10. That FSU victory was the first of four in a row for Bobby Bowden after the Gators had won nine in a row (1968–1976). (UF Information Service, John Woodhead.)

The 1978 game score was 38-21 with FSU being victorious. The game in Tallahassee was the first in which the new FSU mascot, Chief Osceola and his horse Renegade, appeared in the series. This photograph shows them in 1984. Osceola, representing a great Seminole leader, rides his horse at home football games to midfield and plants a burning spear into the turf. (State Archives of Florida, Florida Memory, photographer Deborah Thomas.)

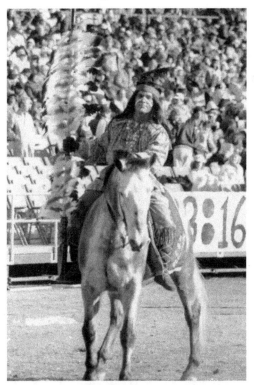

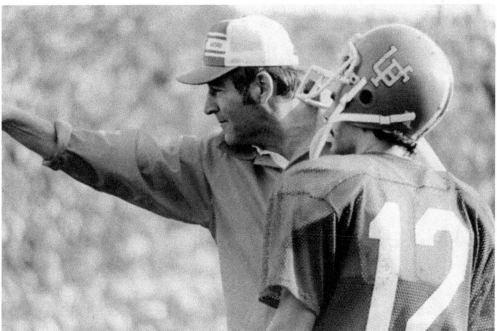

The 1978 game turned out to be a defensive battle, especially in the second half. Here, Coach Dickey directs his quarterback John Brantley in the game. It was the first time that FSU had won consecutive victories over the Gators. (UF News & Public Affairs, John Woodhead.)

The 1978 Gator coaches' photograph showed a past and future Gator great, Steve Spurrier (standing at far right). By the end of the season, the Gator faithful were very disappointed in Coach Dickey and demanded his removal after a disappointing 58-43-2 record during his nine-year tenure at Florida (1970–1978). (UF News & Public Affairs.)

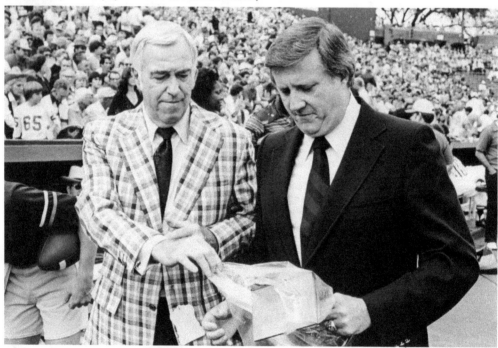

The athletic programs at both schools had generous supporters; for example, New York Yankees' owner George Steinbrenner (right) is seen here with UF athletic director Ray Graves. Steinbrenner helped fund a band building and—for the UF College of Veterinary Medicine—a large-animal hospital and an equine imaging machine. (UF News & Public Affairs, John Woodhead.)

In 1979, FSU defeated UF 27-16. That year, UF replaced Doug Dickey as head coach with Charley Pell. Pell had done very well coaching Jacksonville State (1969–1973) and Clemson (1977–1978), so he was expected to do well at Florida, maybe winning an SEC championship and even a national championship. That first season, however, ended with a terrible 0-10-1 record. (UF Information Services, Marshall Prine.)

The 1979 UF-FSU match was held before 58,263 fans at Florida Field on the Friday after Thanksgiving. This photograph shows handshakes before the game. The Seminoles won the game and went on to their first perfect regular season, 11-0. They lost to Oklahoma in the Orange Bowl, but it was a great season for Seminole fans. (UF Information Services, Marshall Prine.)

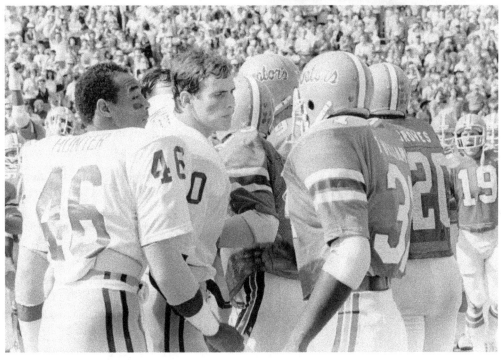

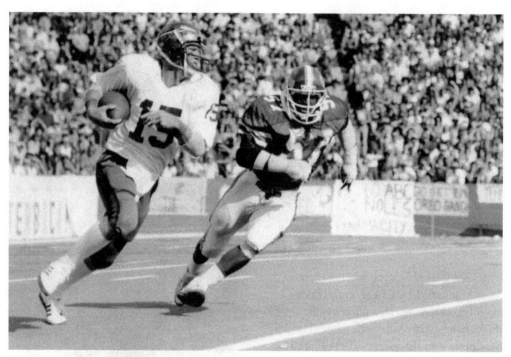

FSU's quarterback, Jimmy Jordan (No. 15), shown here being chased by UF's Tim Golden (No. 57), was complemented by a second quarterback, Wally Woodham, and a strong defense, led by consensus All-American Ron Simmons. Simmons went on to set FSU's season record for most tackles for a loss (17), and Mark Bonasorte tied the school record for most interceptions in one season (8). (UF Information Services.)

The Seminoles also held the great Gator receiver Cris Collinsworth, pictured here, to five catches in the 1979 game. During his football career at UF (1977–1980), he at first played quarterback and, in his first game as a Gator, threw a 99-yard touchdown pass to Derrick Gaffney, which remains tied for the longest touchdown pass in NCAA history. (UF Sports Information.)

1 9 8 0 S

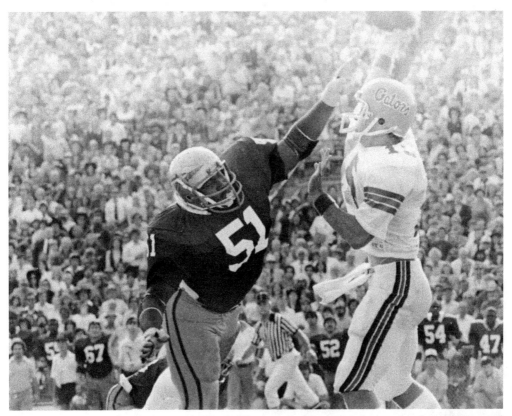

The 1980 game score was FSU 17 to UF 13. This year began the tradition of making the annual game the last one in the regular season. The 1980 game, an FSU win at 17-13, was closely fought, but became FSU's fourth win in a row over the Gators. Here, UF's Wayne Peace throws over FSU's James Gilbert (No. 51). (UF Information Services, Marshall Prine.)

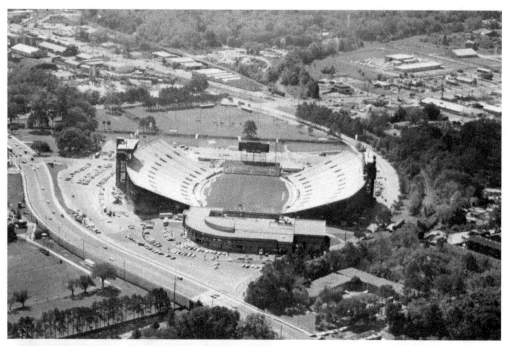

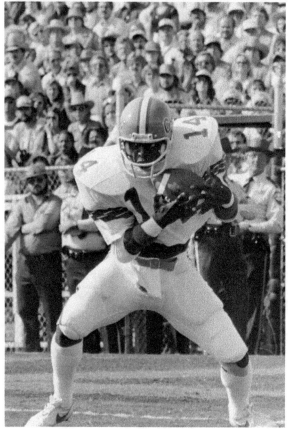

The 1980 Seminole seniors, led by repeat All-American Ron Simmons, defensive back Bobby Butler, and offensive tackle Ken Lanier, the latter pair both future NFL stars, finished their college careers without losing to their in-state foe. Doak Campbell Stadium had 53,772 in attendance for the UF-FSU game in 1980. (State Archives of Florida, Florida Memory, photographer Phil Coale.)

UF's Johnell Brown was one of the Gator runners held in check that day. Despite the loss, the Gators were the first in college football history to go winless one season (1979) and then go to a bowl at the end of the next season, one in which the team finished 9-4. (UF Information Services, Marshall Prine.)

The Gators were back on top in 1981, 35-3. In 1981, Cecil "Hootie" Ingram became athletic director at FSU and launched a very successful $10-million building program for athletic facilities at the school. The high-quality caliber of such men as Ingram and, later, Jeremy Foley at UF did much to attract outstanding athletes to each school. (State Archives of Florida, Florida Memory, photographer Mark Foley.)

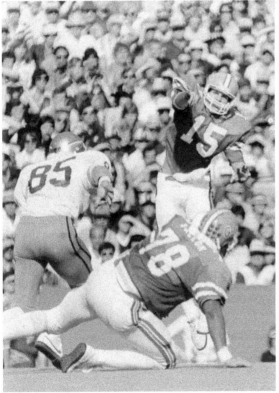

Here, during the 1981 game, UF's Wayne Peace (No. 15) is throwing over teammate Russell Gallon (No. 78) and FSU's David Ponder (No. 85). He completed 20 of 33 passes—with four touchdowns, no interceptions, and an impressive 275 of the Gators' 437 total yards of offense on their way to a 35-3 victory, the series' greatest rout since the UF victory over FSU 49-0 in 1973. (UF Information Services, Marshall Prine.)

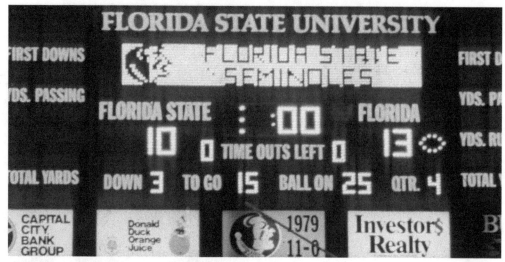

A close, low-scoring game occurred in 1982, with UF winning 13-10. The scoreboard in Campbell Stadium that day showed the final score after the two rivals met for the 25th time. The Seminoles were the second-highest scoring team in the nation, with a 35.3 average. Much of that may have been due to Mike Kruczek, formerly a Pittsburgh Steelers quarterback, who coached the FSU quarterbacks. (UF Archives.)

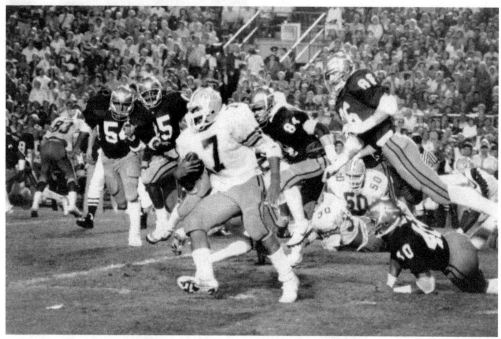

Fans expected an aerial show from the two teams in 1982, but the drizzly conditions favored runners instead. The difference was the Gators' Lorenzo Hampton (No. 7), who had a career-high 138 yards on 23 rushes. Another Gator, Neal Anderson, had 103 yards on 13 carries, his third-straight 100-yard game. For the Seminoles, Ricky Williams rushed for 110 yards, and Greg Allen had 81 yards. (UF Information Services.)

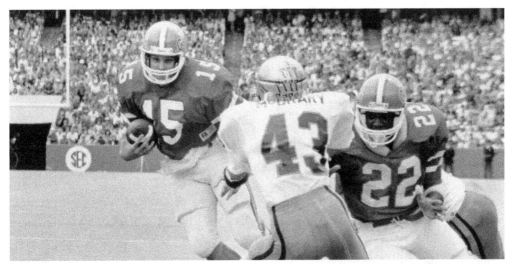

In 1983, a record 74,000-plus attended the annual game. Most expected a close game, but the Gators won, 53-14, in the most one-sided win in the annual match since UF's 49-0 victory in 1973. It was the last game at Florida Field for Gator quarterback Wayne Peace (No. 15), pictured running behind John L. Williams (No. 22) against FSU's Brian McCrary (No. 43). (UF Information Services, Neil Berger.)

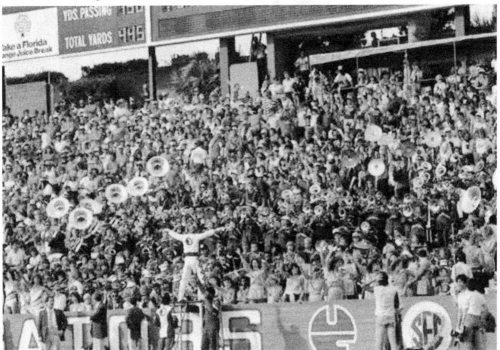

In the 1983 season, FSU's Marching Chiefs, pictured here at Florida Field in the early 1980s, came up with the distinctive tomahawk chop to urge on their team. The monotone war chant and back-and-forward motion of the open hand was meant to wave the Seminoles on to victory. (State Archives of Florida, Florida Memory, photographer Deborah Thomas.)

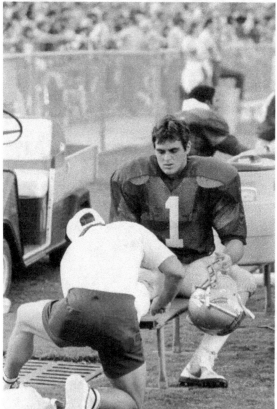

Seminole fans liked celebrating important wins like that over the Miami team in October 1984. But that would not happen after the UF-FSU game that year, since the Gators won 27-17 on a rainy evening that slowed down the Seminoles, the No. 1 scoring team in the nation with an average of over 37 points a game. (State Archives of Florida, Florida Memory.)

FSU's Eric Thomas (No. 1), seen here getting his leg attended to on the sidelines that fall, was one of the quarterbacks that Coach Bowden relied on during the 1984 season. Another was Kirk Coker. The 1984 game was played before a record 58,000-plus fans and a national television audience. (State Archives of Florida, Florida Memory, photographer Deborah Thomas.)

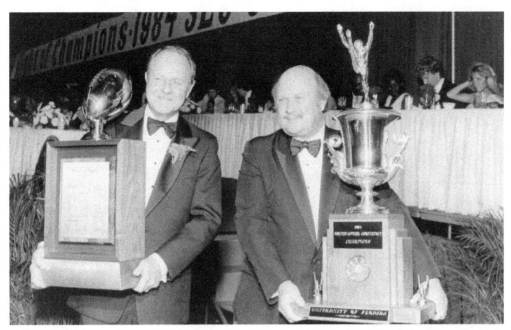

The game's final score in 1985 was UF 38 to FSU 14. UF hired a new head coach, Galen Hall, whose team then won the next eight games, but SEC officials barred the Gators from playing in any postseason bowls for recruiting violations and stripped the SEC title from them. UF president Marshall Criser (left) and Coach Hall still managed to claim several trophies for that season. (UF News & Public Affairs, Bruce Fine.)

During the 1985 game, Deion Sanders (No. 2) returns a punt for a touchdown for FSU while Terry Robinson (No. 15) celebrates, but UF prevailed, relying on quarterback Kerwin Bell, who completed 14 of 22 passes for an impressive 343 yards and three touchdowns. (UF Information Services, Lee Malis.)

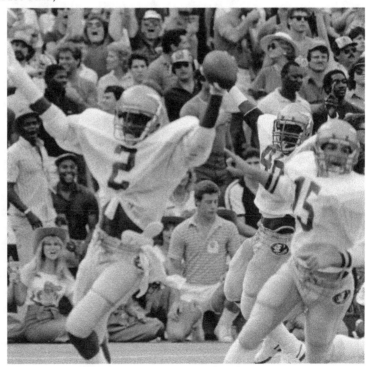

The Gators considered the 1985 game with the Seminoles to be their own bowl game since NCAA probation did not allow them to compete in any postseason games. After the game, their final one of the season, senior spokesman Neal Anderson (No. 27) thanked the Gator fans for supporting them that year. (UF Information Services.)

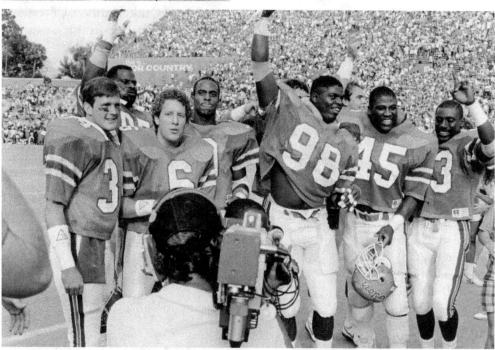

The Gators celebrate after the 1985 game. The win enabled them to be the first Florida team to win nine games in three consecutive seasons. The Seminoles ended the season ranked 15th by the United Press International (UPI) and 13th by the Associated Press (AP). Their final record was 9-3. (UF Information Services, Neil Berger.)

The 1986 game score was UF 17 to FSU 13. Athletes from both schools, including Gator quarterback Kerwin Bell, shown here addressing schoolchildren, did much good by going into schools and encouraging the students to study hard, avoid bad habits, and support their local teams. The students always seemed to enjoy meeting such athletes and hearing their advice. (UF Information Services, Walter Coker.)

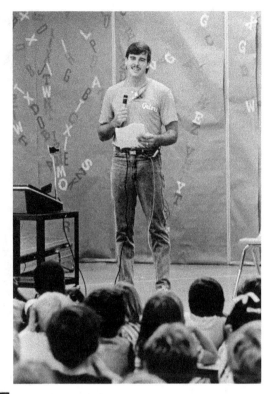

FSU head coach Bobby Bowden, seen here giving his players a pep talk before the start of the 1986 season, was becoming a very effective recruiter and motivator for his teams. His final career record of 377-129-4 would lead to his induction into the College Football Hall of Fame. (State Archives of Florida, Florida Memory, photographer Phil Coale.)

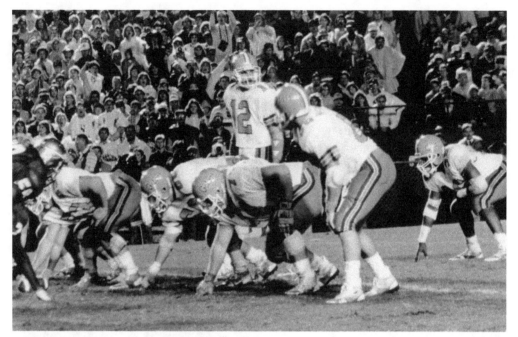

Many of the record crowd of 60,307 fans at Doak Campbell Stadium that November evening in 1986 were hoping for an end to the five-game losing streak to the Gators, but it was not to be. Toward the end of the game, the Gators' Coach Hall had Kerwin Bell (No. 12), seen here looking over the lines, throw the winning touchdown to Ricky Nattiel. (UF Information Services, Neil Berger.)

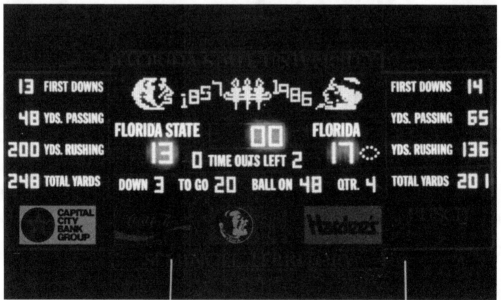

The final tally showed that the Seminoles had gained 248 yards, 47 more than the Gators. Freshman Seminole Sammie Smith rushed for 116 yards on 24 carries and gave a glimpse of what a great career he would have at FSU. The Gators finished the season with a disappointing 6-5 record, whereas the Seminoles had a better 7-4-1 record. (UF Information Services, Neil Berger.)

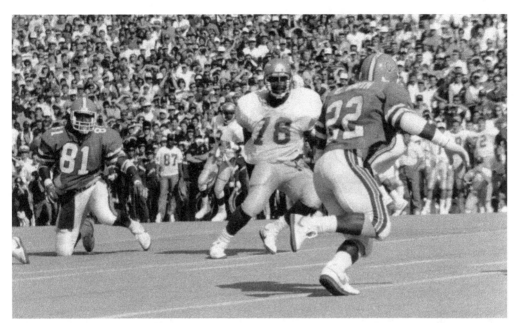

In 1987, the Gators had freshman sensation Emmitt Smith (No. 22), who would end the season with an amazing 1,341 yards, which set the Florida record for rushing yardage. In the 1987 game, he carried 20 times for 100 yards. Here, FSU's Eric Hayes (No. 78) gets by UF's Clifton Reynolds (No. 81) to try to stop Emmitt Smith (No. 22). (UF Information Services, Neil Berger.)

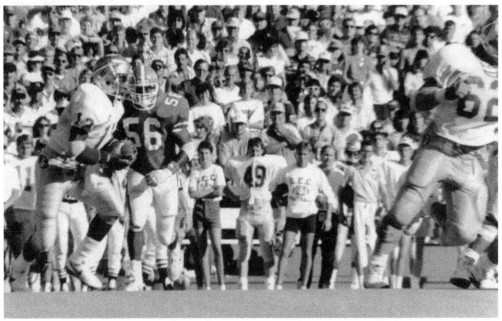

That November, the 9-1 Seminoles faced the 6-4 Gators in Gainesville and outlasted the latter to win 28-14. Here, UF's Clifford Charlton (No. 56) chases FSU's Rick Tuten (No. 12) while Jason Kuipers (No. 62) blocks. The Seminoles had more first downs than the Gators, 26-11. (UF Information Services, Neil Berger.)

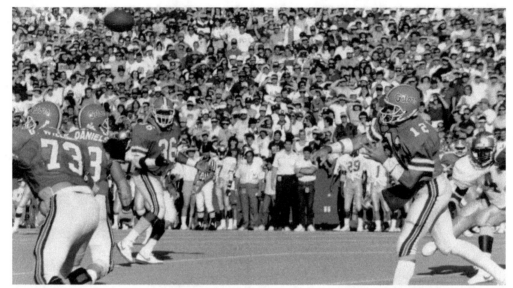

UF's senior quarterback Kerwin Bell (No. 12) passes over the heads of David Williams (No. 73), Tracy Daniels (No. 63), and Anthony Williams (No. 36). The Seminoles won the first of four games in a row after losing the previous six in a row. They finished the 1987 season 11-1 and ranked second nationally in the AP and UPI polls. (UF Information Services, Neil Berger.)

Both schools were in the process of changing their mascots. Here is the "new" Albert with his companion, Alberta, at UF during a football game. Other schools have used the alligator as a mascot, but no other school has become so identified with the gator as UF. (UF News & Public Affairs, Chris Runk.)

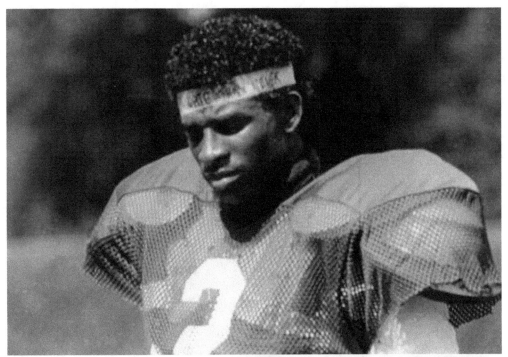

In 1988, the Seminoles smashed the gators, 52-17. While at FSU, Deion Sanders set records for career punt return yards and for the longest interception return for a touchdown. In 1988, he won the Jim Thorpe Award, given to the nation's top defensive back. He led the nation in 1988 with his punt return average. (State Archives of Florida, Florida Memory, photographer Donn Dughi.)

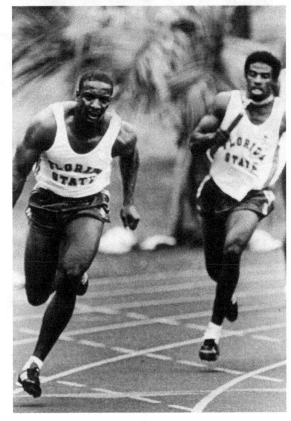

Football players Sammie Smith (left) and Deion Sanders (right) also ran for FSU's track team. Both players did well in 1988's 52-17 victory over the Gators, FSU's most one-sided win in the series up to that point. The Seminoles finished the season with a Sugar Bowl win and a third-place ranking in both polls. (State Archives of Florida, Florida Memory, photographer Mike Ewen.)

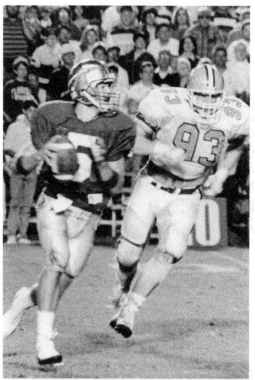

UF's Trace Armstrong (No. 93) chases FSU's Chip Ferguson (No. 5) in the 1988 game. Quarterback Ferguson was 10 of 16 for 131 yards and three touchdowns. The Seminoles outgained the Gators 414 yards to 183 and had twice as many first downs. The Sugar Bowl appearance at the end of the season was the team's seventh straight bowl appearance. (UF Information Services, Buddy Long.)

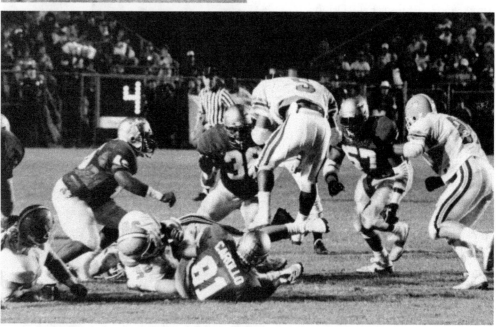

FSU's Phil Carollo (No. 81), Jason Crain (No. 38), and Corey Senior (No. 57) close in on UF's Willie McClendon (No. 5). After an initial loss to Miami, FSU had won nine consecutive games in 1988 going into their annual rivalry game with UF and were on a roll. The Seminoles won eleven games and lost only one that season. (UF Information Services, Buddy Long.)

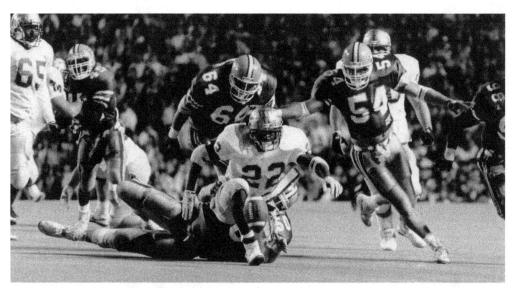

In 1989, the 8-2 Seminoles traveled to Gainesville to meet the 7-3 Gators, and the match ended in an FSU victory, 24-17. Here, UF's Mark Murray (No. 54) and Phillip Johnson (No. 64) and FSU's Edgar Bennett (No. 22) chase a loose ball. UF's Emmitt Smith had his best day against the Seminoles, carrying the ball 30 times for 153 yards. (UF Information Services, Walter Coker.)

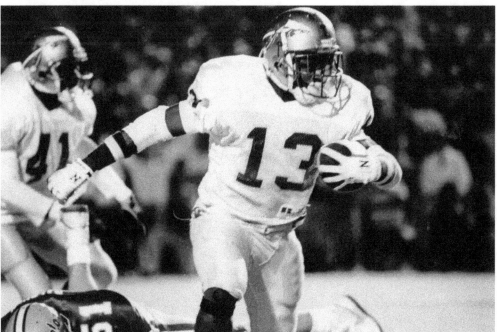

One of FSU's strong runners was Dexter Carter (No. 13), seen here leaving teammate Chris Hall (No. 41) and UF's Greg Baldwin (No. 51) behind. In 1990, the San Francisco 49ers drafted Carter in the first round, one of many players on both teams drafted in the early rounds over the years. The Gators' strong running back, Emmitt Smith, would turn pro at the end of the 1989 season. (UF Information Services, Walter Coker.)

The difference in the 1989 game was FSU quarterback Peter Tom Willis (No. 4), seen here passing while teammates Kevin Mancini (No. 67) and Tony Yeomans (No. 70) block and UF's Mark Murray (No. 54) closes in. Willis completed 20 of 32 passes for 319 yards in one of the most productive outings yet for a Seminole quarterback. (UF Information Services, Walter Coker.)

Tailgating before and after the games has long been popular. At tailgates, friends and family members consume all kinds of beverages and grilled food. People usually park in the same parking space for each game and brag about their teams while disparaging other teams. (UF Information Services, Ray Carson.)

5

1990S

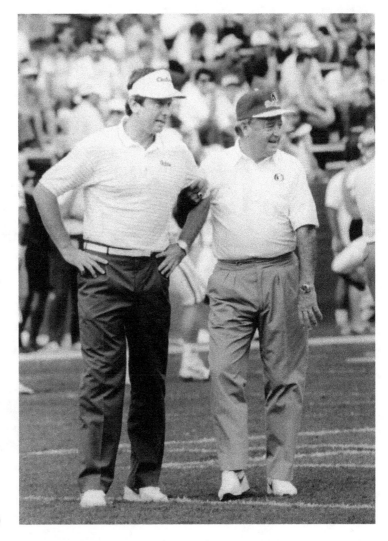

The 1990 game ended with FSU as the victors, 45-30. In 1990, Steve Spurrier, who had won the Heisman Trophy when he quarterbacked the Gators in 1966, became the Gators' head coach and ushered in a high-powered "fun-'n'-gun" offense for the next 12 years. Here, Coach Spurrier (left) and Coach Bowden share a few quiet moments before the 1991 game. (UF Information Services, Buddy Long.)

To run his high-octane offense, Spurrier had quarterback Shane Matthews (No. 9) at the helm. In that game, Matthews completed 29 of 48 passes for 351 yards, but it was not enough, and FSU won 45-30. The 75 total points were the most ever scored in the series, but it would be expected more and more by the fans of both teams. (UF Information Services, Gene Bednarek.)

During Spurrier's 12 seasons, the UF-FSU rivalry reached its peak of national importance. Often, ESPN had its famous Game Day broadcast from the scene of the annual game. Such publicity brought good exposure of the schools and their cities to the viewing public throughout the country. (UF News & Public Affairs.)

The Gators' home stadium, Ben Hill Griffin Stadium, had an impressive main entrance. Gator fans would line the walk in front of the entrance and greet the players coming off the buses before they entered the stadium. (UF Information Services.)

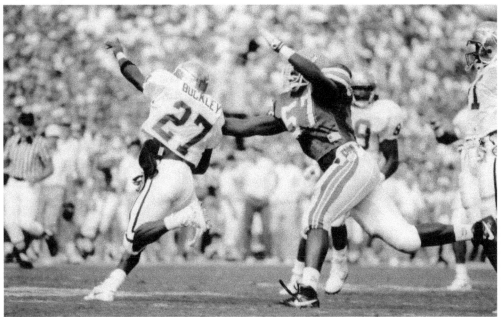

FSU's All-American Terrell Buckley (No. 27), seen here being chased by UF's Kevin Carter (No. 57), had two interceptions that day. In the 1991 season, he set an NCAA record for career return yards (501) off interceptions (21). Coach Spurrier called that game "the most intense, emotional, electrifying game I have ever been involved with as a player or coach at any level." (UF Information Services, Buddy Long.)

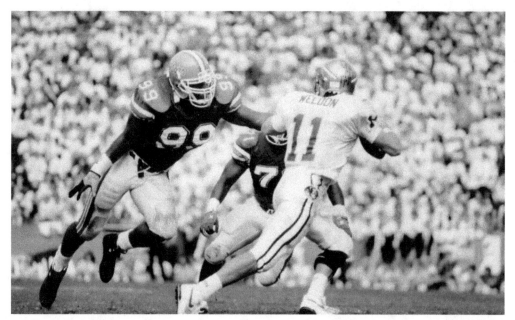

In the end, the 1991 game turned into a defensive battle, which UF won 14-9. FSU's great quarterback, Casey Weldon (No. 11), seen here being chased by UF's Tim Paulk (No. 99), was harassed by the defense much of the day and needed seven stitches to close a cut on his chin in the first quarter. (UF Information Services, Buddy Long.)

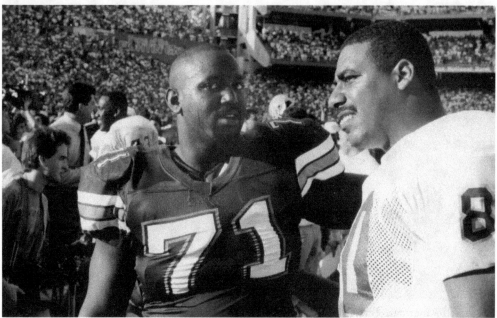

After the game, players from each team met on the field. Here, UF's Tony McCoy (No. 71) and FSU's Johnny Clower (No. 80) share a few moments. As so often happened, former high school teammates were on different sides in college but still remained friends. (UF Information Services, Buddy Long.)

By the time the two rivals met at Doak Campbell Stadium in November 1992, both teams were ranked in the AP's top 10. FSU was third, and UF was sixth. By game time, the Seminoles were 9-1, and the Gators were 8-2. In the end, the no-huddle shotgun formation that FSU quarterback Charlie Ward used blew out the Gators, 45-24. (*Gainesville Sun*, Stephen Morton.)

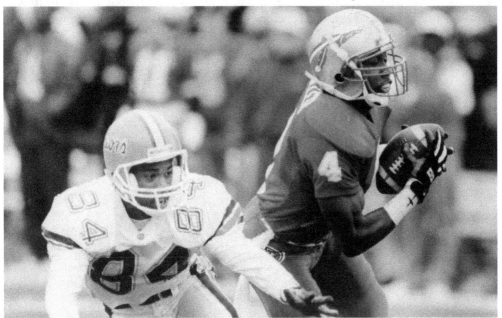

Here, FSU's Corey Fuller intercepts a pass intended for UF's Harrison Houston. The FSU defense was particularly strong that day, led by consensus All-American Marvin Jones, whom some consider the greatest linebacker ever to play for the Seminoles. The Seminoles' first season in the Atlantic Coast Conference produced the rivalry's first inter-conference battle, the ACC vs. the SEC. (*Gainesville Sun*, Stephen Morton.)

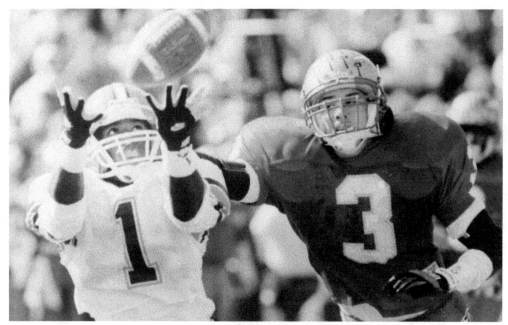

UF's Jack Jackson (No. 1) reaches for a pass behind FSU's Leon Fowler (No. 3). In the end, FSU's offense edged UF's, 471 yards to 354. The stars of the game were FSU's quarterback Charlie Ward, Tallahassee freshman kick returner/receiver Tamarick Vanover, and a strong defense. By the end of the season, the Seminoles were ranked second in the nation, and the Gators were ranked tenth. (*Gainesville Sun*, Stephen Morton.)

It was Coach Spurrier who nicknamed the UF stadium "the Swamp," because, in his words, "a swamp is where Gators live. A swamp is hot and sticky and can be dangerous. Only Gators get out alive." Both teams succeeded in making their own stadium a place where they seldom lost. (UF Archives, Ray Carson.)

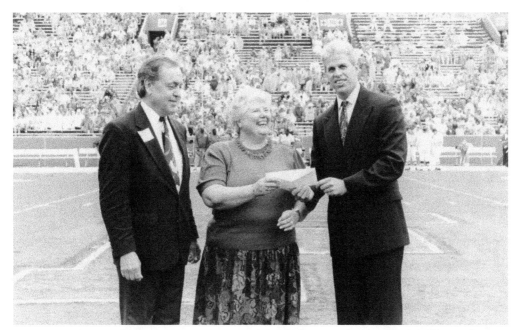

The Seminoles were back on top in 1993, 33-21. The athletic teams of both schools were generous to the academic programs of their respective universities. This photograph shows UF athletic director Jeremy Foley (right) presenting a check to provost Andrew Sorenson (left) and director of the libraries Dale Canelas (center) in 1993. The money was generated from bowl and television appearances. (UF News & Public Affairs, Jeff Gage.)

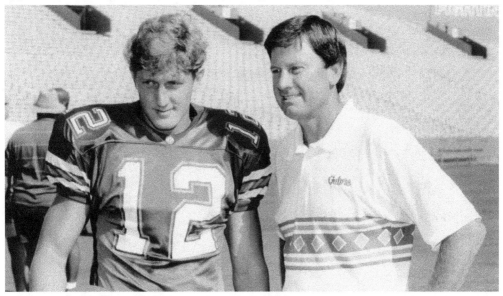

Terry Dean, seen here with Coach Spurrier, replaced freshman Danny Wuerffel, who sustained minor cartilage damage in his right knee in the 1993 FSU game. The Gator football team was so successful in the 1990s that they averaged over nine television appearances each year of the decade. (UF News & Public Affairs.)

FSU, which came into the 1993 game at 10-1 with aspirations for playing for the national championship, was led by quarterback Charlie Ward (No. 17), who threw the winning touchdown pass to freshman receiver Warrick Dunn. The Seminoles won before a record crowd of 85,507 fans and went on to win the 1993 national championship. (State Archives of Florida, Florida Memory.)

Coach Spurrier's 1993 coaching staff included, from left to right, Red Anderson, Charlie Strong, Jim Collins, Bob Sanders, Ron Zook, Steve Spurrier, John Reaves, Dwayne Dixon, Jimmy Ray Stephens, and Carl Franks. As was true at FSU, as the team's success increased, the assistant coaches became head coaches elsewhere. (UF News & Public Affairs.)

In the 1994 season, the two teams met twice, once in the regular season and then in the Sugar Bowl in January 1995. In the first meeting, the Gators led 31-3 at the start of the fourth quarter, but what ensued was an amazing turnaround, something called the "Choke at Doak." Here, FSU's Corey Fuller (No. 4) helps anchor a strong Seminole defense. The game ended in a tie, 31-31. (UF Archives.)

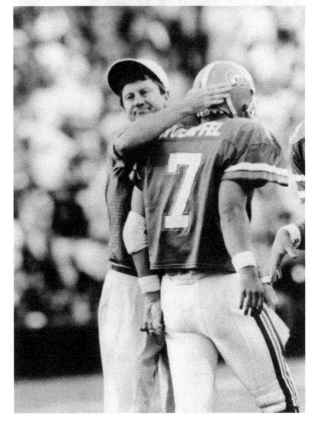

On the way to that substantial 31-3 lead, UF quarterback Danny Wuerffel (seen here with Coach Spurrier the following year) was 14 of 26 for 263 yards and three touchdowns, but—when the Gators went into a keep-the-lead offense—he was only 3 of 6 for 26 yards. (UF Archives.)

One of the FSU stars in the 1994 game was Warrick Dunn (No. 28), seen here in another game scoring a touchdown. The tie game nixed any chance that either team would play for the national championship, but they would meet again in the Sugar Bowl in January 1995. (State Archives of Florida, Florida Memory.)

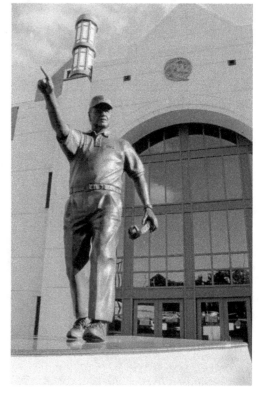

The Seminoles scored a touchdown late in the game, and Coach Bowden chose to have Dan Mowrey kick a point-after-touchdown, which tied the score at 31. The FSU coach, later honored with a bronze statue outside Doak Campbell Stadium, chose not to take a chance that the two-point conversion would fail and thus really dishearten his players and Seminole fans. (State Archives of Florida, Florida Memory, photographer Beatrice M. Queral.)

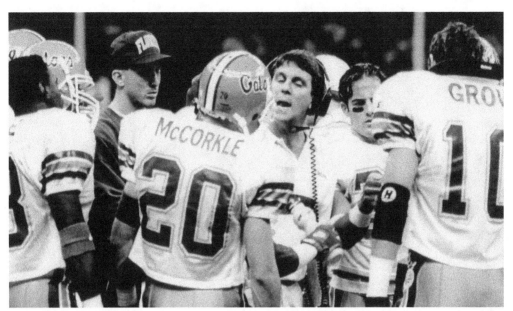

UF assistant coach Ron Zook (with the headset in the middle of his players) was one of Coach Spurrier's coaches in the Sugar Bowl in early January 1995, when FSU and UF met for the second time that season. The Seminoles won the rematch with the Gators 23-17. (UF Archives.)

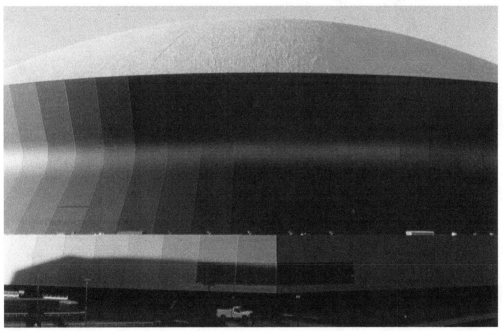

The match between UF and FSU in the post-1994 season was in the Louisiana Superdome in New Orleans. The Seminoles had won the ACC for the third straight year, and the Gators had beaten Alabama in the 1994 SEC championship game to win the conference for the second year and go to the Sugar Bowl for the third time in three years. (Photograph by Rafal Konieczny, Wikimedia Commons.)

One of the stars of the rematch was FSU's Warrick Dunn, shown here as an NFL running back addressing US service members in Afghanistan in 2009. Dunn had a very successful career at FSU, where he graduated in 1997. Among the FSU records he held were most rushing yards in a season (1,418, set in 1995) and most career rushing yards (3,959). He was a three-time All-ACC choice and the only Seminole to rush for over 1,000 yards in three consecutive seasons. He played in the NFL for 12 seasons, during which time he was named AP NFL Offensive Rookie of the Year in 1997 and earned three Pro Bowl selections. He also established both the Homes for the Holidays program in 1997 and the Warrick Dunn Charities in 2002 as a way to give back to the communities he had worked in. (Photograph by MC1 Chad J. McNeeley, US Navy, Wikimedia Commons.)

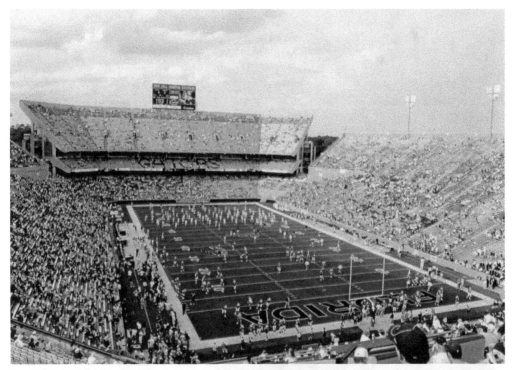

In 1995, UF prevailed against FSU, 35-24. UF's Swamp was gaining a reputation for being one of the loudest football stadia in the country. Officials estimate that it is the 12th largest college football stadium if measured by official seating capacity (88,548), but attendance for Gators home football games often exceeds 90,000 people. (Bill Ragan, Shutterstock.com.)

One of the fixtures at Gator home games was "Mr. Two Bits," George Edmonson Jr., who led Gator fans for many years at Florida Field. He would lead the cheers just before the players took the field. The tradition of the "Two Bits" chant began in 1949 as a method of drowning out the booing that the fans were directing at an inept Gator squad. (UF News & Public Affairs, Jeff Gage.)

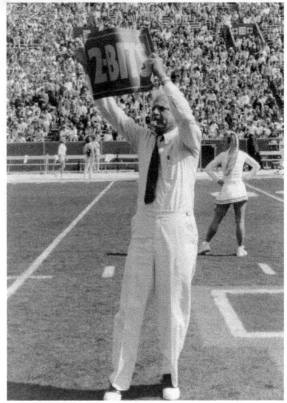

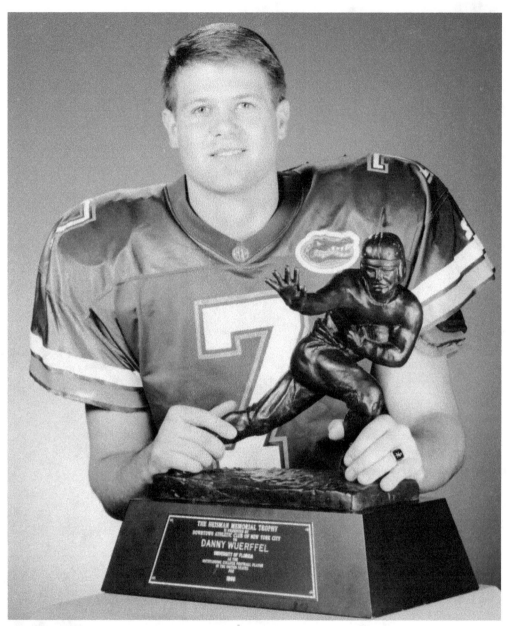

Coach Bowden knew that a win in Gainesville for his team in 1995 would probably mean a match-up in the Fiesta Bowl against top-ranked Nebraska for another chance at the national championship, but it was not to be. The No. 3 Gators beat the No. 6 Seminoles 35-24, finishing UF's first undefeated regular season. FSU was 9-1 up to that point, but were no match for the aerial show put on by Coach Spurrier and his star quarterback Danny Wuerffel. The UF quarterback had an amazing 443-yard, four-touchdown performance, adding to his statistics for the following year's Heisman Trophy win. Wuerffel is shown here with the Heisman Trophy, which he won in 1996. He led the nation in touchdown passes in 1995 and 1996 and set many school and conference records. He was inducted into the College Football Hall of Fame in 2013. (UF Archives, Ray Carson.)

In the regular season game in 1996, FSU beat UF, 24-21. When No. 1 UF played No. 2 FSU in Tallahassee that year, both were undefeated. UF quarterback Danny Wuerffel had a bad first half, throwing three interceptions, but regained his composure and then threw for three touchdowns. Wuerffel (No. 7) is shown here talking to his successor, Doug Johnson (No. 12), at practice that season. (UF News & Public Affairs, Jeff Gage.)

One of the stars for FSU in the 1996 game was the great running back Warrick Dunn, seen here on the FSU sidelines the following year. He rushed for an impressive 185 yards in the 1996 regular-season game against UF, had four receptions, and even completed a pass for 10 yards and a first down. (State Archives of Florida, Florida Memory.)

Gator defensive coordinator Bob Stoops, seen here on the UF practice field teaching his players, would go on to coach the University of Oklahoma Sooners to a national championship in the 2000 season. Many coaches from both teams were so good that they went on to other schools as head coaches. (UF Archives, Jeff Gage.)

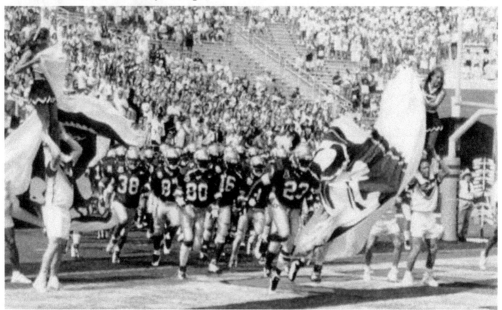

The entrance of the Seminole football team to the field at Doak Campbell Stadium in the mid-1990s was noisy and spirited. It would become even more full of pageantry as the marching band and mascot evolved in the 2000s. The cheers and music before the game were meant to prepare the fans for the ensuing match. (State Archives of Florida, Florida Memory.)

In their postseason game, played in 1997, UF won against FSU, 52-20. After UF won the SEC championship that season, the Gators met the Seminoles in a rematch in the Sugar Bowl in January. The Gators won for their first national championship in their 90-year history. Whether after the Gators scored a touchdown or played poorly, Coach Spurrier showed his emotions. (UF News & Public Affairs, Jeff Gage.)

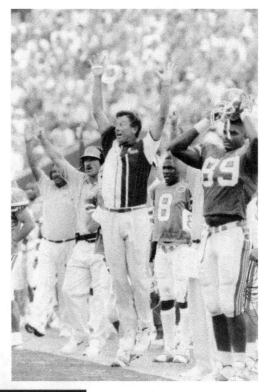

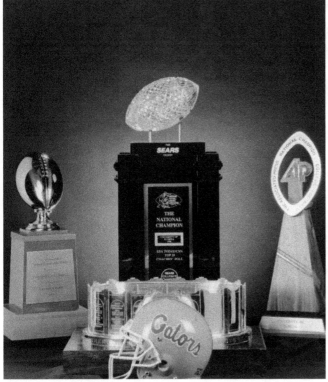

As FSU proudly displayed its 1993 championship trophy, so did UF display its 1996 championship trophy. Each year, the American Football Coaches Association (AFCA) awards the trophy, also called the Sears Trophy during the years 1993–2001 when Sears, Roebuck & Company sponsored it. Such recognition for the excellence of the football program at both schools helped recruit outstanding athletes to continue that tradition. (UF News & Public Affairs, Ray Carson.)

To protect his quarterback from the strong FSU defense, Coach Spurrier used the shotgun formation, and Wuerffel threw for 306 yards and three touchdowns. Wuerffel became the second Heisman Trophy winner in four years to win a national championship game, following in the footsteps of FSU's Charlie Ward in 1993. On its football tickets in the following season, UF proudly announced its champion status. (UF News & Public Affairs, Jeff Gage.)

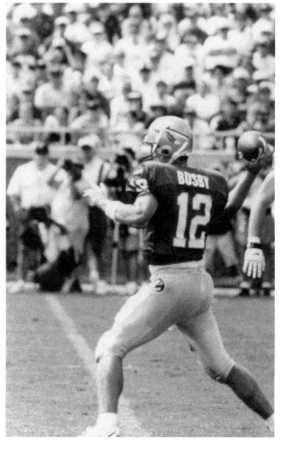

Two of the stars for FSU in the championship game were running back Warrick Dunn, who scored a touchdown, and quarterback Thad Busby, who threw for a touchdown. Busby, pictured here in 1997, later played in the Arena Football League and for the San Francisco 49ers and Cleveland Browns of the NFL. (State Archives of Florida, Florida Memory.)

No. 1 FSU was undefeated when the Seminoles went to Gainesville to play the No. 10 Gators in late 1997. After a fight broke out before the game, the two teams settled down, and UF won the game with a last-minute touchdown, 32-29. During the game, Spurrier used two quarterbacks, Doug Johnson and Noah Brindise (No. 17), shown here on the field. (UF News & Public Affairs, Jason.)

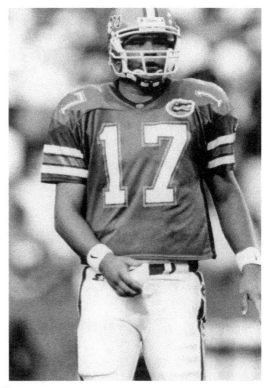

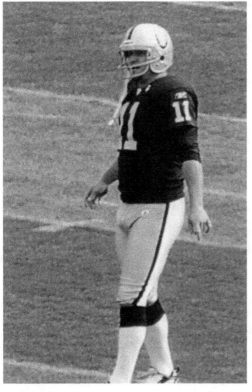

One of the stars for FSU in that game was place-kicker Sebastian Janikowski, who kicked three field goals to keep the Seminoles in the game. Janikowski, seen here in his NFL Oakland Raiders uniform, was a two-time consensus All-American before going on to play professional football for the Raiders, beginning in 2000. (© BrokenSphere, Wikimedia Commons.)

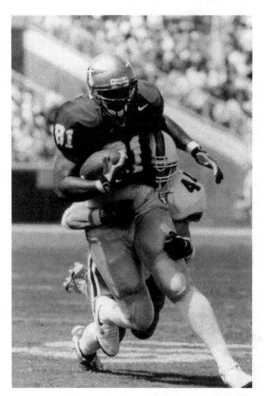

One of the best FSU players from 1994 to 1997 was tight end Melvin Pearsall, whom some have named to the all-FSU squad. During his career, Pearsall, seen here in 1997, had 63 receptions for 742 yards and 11 touchdowns. He was actually recruited out of Lake Wales High School as a linebacker but switched to tight end. (State Archives of Florida, Florida Memory.)

One of the Gators' best players in the 1997 game was receiver Jacquez Green, who caught a 62-yard pass from quarterback Doug Johnson. Green, who lettered for three years at UF (1995–1997), was also a good kick returner, holding school records for a single season (392 yards on 27 returns in 1997) and for a career (766 yards). (UF News & Public Affairs, Herb Press.)

The 23-12 Seminole victory in Tallahassee in 1998 was the start of three straight FSU victories. Several players were ejected after a fight broke out before the game. Gator quarterback Doug Johnson (No. 12), seen here trying to elude a defender, had a 50-yard passing play, but the Seminole defense held the Gators scoreless in the second half. (UF News & Public Affairs, Jeff Gage.)

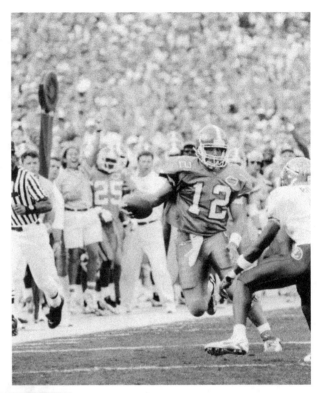

FSU's offensive coordinator Mark Richt had his teams consistently ranked in the nation's top-five scoring offenses. He also coached two Heisman Trophy–winning quarterbacks, Charlie Ward and Chris Weinke, and was part of two national championships (1993, 1999) before becoming the head coach at the University of Georgia in 2001 and the University of Miami in 2016. (Photograph by S.Sgt. Christina M. Styer, US Air Force.)

The Seminoles beat the Gators 30-23 in 1999 despite the two-quarterback system of Doug Johnson and Jesse Palmer that UF coach Steve Spurrier used that season to deal with quarterback injuries. Jesse Palmer (No. 7) was one of the many quarterbacks who played at UF under Coach Spurrier. (UF News & Public Affairs, Jeff Gage.)

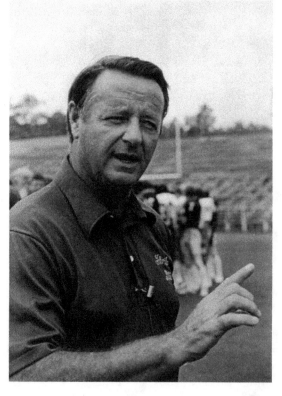

The 1999 season was one of Coach Bowden's best years. While at FSU, his teams won the AP and Coaches' Poll national title (1993) and the Bowl Championship Series (BCS) national championship (1999), as well as 12 ACC championships since the school joined that conference in 1991. For decades, he was the head football coach most closely associated with FSU. (State Archives of Florida, Florida Memory, photographer Deborah Thomas.)

2000S

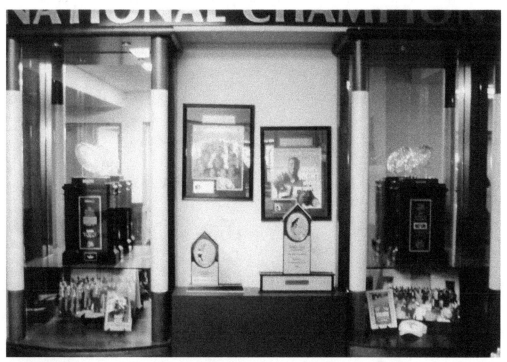

In 2000, FSU won the game 30-7, primarily because of Seminole quarterback Chris Weinke and the stingy defense of the Seminoles. Bobby Bowden's teams were consistently winning games and awards, as evidenced by the trophy case on campus. He became the only coach in the history of college football to lead his teams to 10 or more wins over 10 consecutive seasons. (cholder68, Wikimedia Commons.)

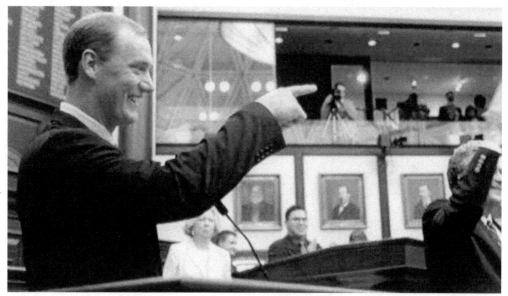

Seminole play-caller Chris Weinke won the 2000 Heisman Trophy at age 28; he was the oldest winner. He spent six years in minor league baseball before enrolling at FSU. He became the second Seminole to win the award, after Charlie Ward in 1993. Weinke, shown visiting the Florida legislature, also won that year's Davey O'Brien Award and the Johnny Unitas Award. (State Archives of Florida, Florida Memory, photographer Mark Foley.)

Coach Spurrier continued emphasizing a pass-oriented offense in contrast to the ball-control, rush-oriented offense that other SEC teams preferred. He was the head coach at three universities (Duke, Florida, and South Carolina) and at two professional teams (Tampa Bay Bandits of the United States Football League [USFL] and Washington Redskins of the NFL). Here, he is shown with Florida governor Lawton Chiles. (UF Archives.)

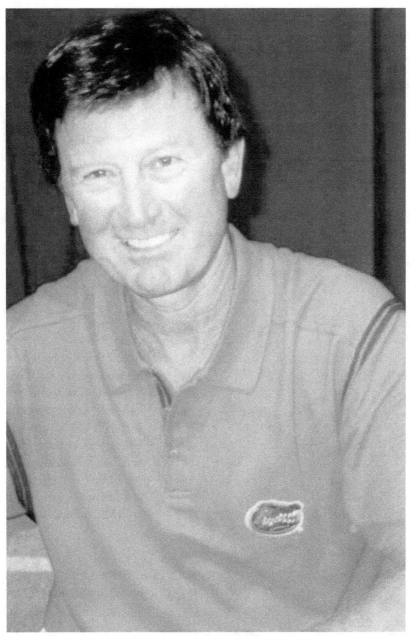

The 2001 game, which ended in a 37-13 win for the Gators, was the 12th and what turned out to be the last, Spurrier-Bowden duel in one of the best in-state football rivalries in America of that era. After the regular season, Spurrier announced that he was resigning. He went on to coach the Washington Redskins in the NFL (2002–2003) and then the South Carolina Gamecocks in 2005, taking that program to much success. In his 12 years as head coach of the Gators (1990–2001), Spurrier's teams won 122 games, lost only 27, and had one tie—for an overall winning percentage of .817, the best for any full-time Gator football coach. He led the team to its first six SEC championships and its first consensus national championship (1996). (Zeng8r, Wikimedia Commons.)

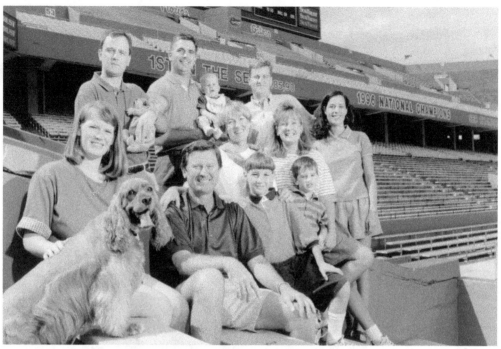

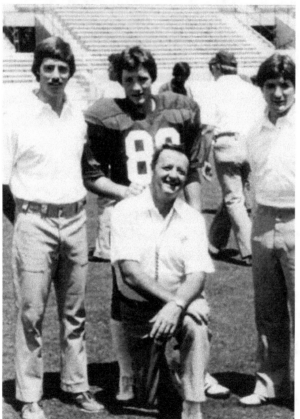

Coach Spurrier, pictured here with his family in the late 1990s at the Swamp in Gainesville, brought his fun-'n'-gun high-octane offense to the UF-FSU rivalry and left a lasting legacy on the game. He and Coach Bowden of FSU were two of the best college football coaches in the nation. (UF News & Public Affairs, Ray Carson.)

Coach Bowden, shown here with his three sons, from left to right, Tommy, Jeff, and Terry in 1982, continued at FSU until January 2010. In the Bowden-Spurrier rivalry, UF won 14 games, FSU won 8, and there was one tie. The two head coaches, fierce rivals on the field, got along well off the field and on the golf course. (State Archives of Florida, Florida Memory.)

FSU won the 2002 game 31-14. In that year, UF hired Ron Zook to replace Steve Spurrier, but the new coach struggled his first year. He would be the Gators' head coach for two seasons (2002–2004) before moving on to the University of Illinois at Champaign-Urbana (2005–2011). Pictured is Ron Zook in 2008. (Photograph by MC3 Bryan M. Ilyankoff, US Navy.)

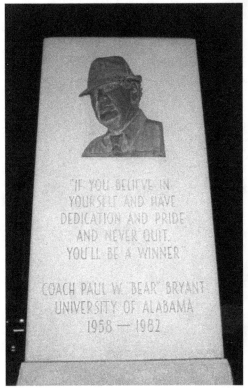

The No. 15 Gators went to Tallahassee in late 2002 and lost to No. 23 FSU. It was the first time since 1986 that neither team was ranked in the AP Top 10. During that season, Coach Bowden passed Alabama's Bear Bryant on the all-time coaching wins list, ending with 377 wins to Bryant's 323. This is Bryant's memorial in Alabama. (Roger3b, Wikimedia Commons.)

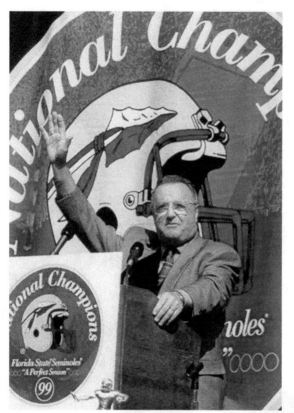

Coach Bowden is pictured here giving a speech to the Florida legislature after the 1999 NCAA championship season. He is honored with a statue outside the stadium, and his name was given to FSU's football stadium, Bobby Bowden Field at Doak Campbell Stadium. (State Archives of Florida, Florida Memory, photographer Mark Foley.)

In postseason play, Bowden's Seminoles lost 26-13 in the Sugar Bowl to the Georgia Bulldogs, coached by former FSU assistant coach Mark Richt; FSU finished 9-5 for the season. Zook's Gators lost 38-30 in the Outback Bowl to Michigan and finished 8-5 for the season. The FSU helmet and logo were becoming better and better known in football circles. (Jnadler1, Wikimedia Commons.)

UF, ranked No. 11, hosted No. 9 FSU in November 2003 in the Swamp, a place where the Gators were usually comfortable in beating opponents. Although the score was close, the Seminoles beat the Gators by four points, 38-34, thanks to the effective passing of FSU's Chris Rix. (Berniestew, Wikimedia Commons.)

Some sportswriters labeled the game "the Swindle in the Swamp" in reference to several questionable calls by the ACC officiating crew dealing with fumbles/no fumbles that went against the Gators. Protests from UF officials led to the practice of having the home team's conference provide the officiating crew, beginning with the 2005 game. (Illegitimate Barrister, Wikimedia Commons.)

With just 55 seconds left in the 2003 game, Seminole quarterback Chris Rix connected with wide receiver P.K. Sam for the winning touchdown in a quarter in which the lead changed hands four times. It would be the last win for the Seminoles at that stadium until 2011. One of the Gator leaders that season was Channing Crowder, seen here later as a Miami Dolphin (No. 52, far right). (Chrisjnelson, Wikimedia Commons.)

After the 2003 game, some Seminole players began jumping on the "F" logo at the center of the field, and a fight broke out among the players of both teams. Later, the FSU athletic director apologized to UF for the incident, and both schools took action to prevent such fights in the future, but they would still occur. The center of each team's field is special. This is a picture of the inside of Ben Hill Griffin Stadium. (Douglas Green.)

When the Gators went to Tallahassee in November 2004, they did something that not even Steve Spurrier's Gators had done: beat FSU in Tallahassee. It was the first time since 1986 that the Gators won at Doak Campbell Stadium. After the 20-13 victory, Coach Zook's players carried him off the field, while Florida fans gave him a standing ovation. (UkrNole 485, Wikimedia Commons.)

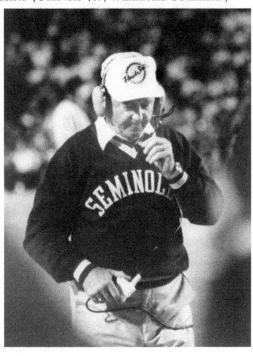

All knew that UF officials had fired Zook, effective at the end of the 2004 season. The victory that year was the first of six in a row for the Gators over the Seminoles. It came after the Seminoles had won two games in a row, one in Tallahassee and one in Gainesville. That evening, Florida State officials named their field after Coach Bowden. (UF Information Services/Brad Windsor.)

Before the 2004 game, officials unveiled a 20-by-30-foot stained-glass window at the stadium that featured Coach Bowden's likeness. The stadium seats 82,300, making it the 15th largest stadium in the NCAA, the largest football stadium in the ACC, and one of the largest continuous brick structures in the United States. (UkrNole 485, Wikimedia Commons.)

In late 2005, the Seminoles went to Gainesville for their annual match with UF, which had added sky boxes to Florida Field. The Gators beat the Seminoles 34-7 in the rivalry's first match for Urban Meyer, newly hired head coach for the Gators. Meyer had come from head coaching positions at Bowling Green State University and the University of Utah. (Douglas Green.)

The Gators consistently sold out their home games at Ben Hill Griffin Jr. Stadium at Florida Field, especially during the Steve Spurrier and Urban Meyer years. Originally built in 1930, the stadium was regularly expanded as the football team improved; today, it can hold over 88,000 fans. It is the 12th largest college football stadium in seating capacity. (Pedro Alcocer.)

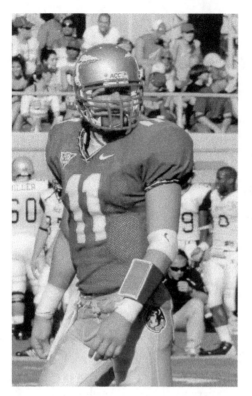

FSU's quarterback Drew Weatherford (No. 11) was one of many highly skilled Seminole quarterbacks over the years, three of whom won the Heisman Trophy: Charlie Ward (1993), Chris Weinke (2000), and Jameis Winston (2013). After being a Fighting Gator at Land O'Lakes High School in Pasco County, Florida, Weatherford became a Seminole at FSU in 2005 and did well at quarterback there. (cholder68, Wikimedia Commons.)

Coach Urban Meyer would lead the Gators back to national prominence, winning the school's second and third national championships in 2006 and 2008, while FSU struggled to regain the success it had known in the 1990s. Coach Meyer, seen here on Florida Field, brought much excitement to the UF-FSU rivalry, first with quarterback Chris Leak and then with quarterback Tim Tebow. (Joel Mclendon.)

When the Gators traveled to Tallahassee in 2006 for their annual match with the Seminoles, the former were marking 100 years of football, dating back to their first season in 1906. The Gators won the 2006 game 21-14, behind quarterback Chris Leak, who had 283 yards of passing and two touchdowns, and receiver/runner Percy Harvin, seen here in 2007 at Florida Field. (Hungry McGrouchypants, Wikimedia Commons.)

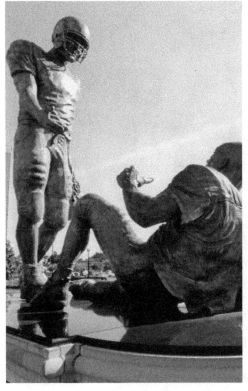

Officials at both schools were hoping that the players would not scuffle, as had happened in the past. FSU officials had erected a 15-foot-tall bronze sculpture by Edward Jones, titled "Sportsmanship," near the stadium. It depicted a standing football player extending his hand to pick up a fallen rival on the field. (State Archives of Florida, Florida Memory, photographer Beatrice M. Queral.)

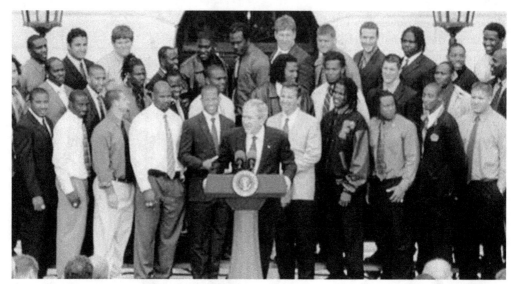

Overcoming what analysts called the toughest football schedule in the nation in 2006 by "opponent winning percentage," the Gators won their seventh SEC title and then defeated the No. 1 Ohio State Buckeyes, 41-14, to win the BCS national championship, finishing with a 13-1 record. They later went to the White House in Washington to be congratulated by Pres. George Bush. (Wikimedia Commons.)

The high quality of football played by both teams enabled them to be on national television many weeks of the season. That no doubt helped in the recruiting of good students and skilled athletes. Part of the pageantry at home games at Doak Campbell Stadium was to have the FSU cheerleaders with their large flags spelling out "NOLES." (cholder68, Flickr.)

The Gators were led by sophomore quarterback Tim Tebow (No. 15), who became the first sophomore to win the Heisman Trophy. In the 2007 FSU game, he accounted for five touchdowns, three passing and two rushing. The Gators celebrated Senior Day at the Swamp by beating the Seminoles 45-12 in front of almost 91,000 fans. (Jameskpoole, Wikimedia Commons.)

The Gators beat the Seminoles in UF's fourth straight victory over their in-state rival, something the Gators had not done since the 1980s. A bright spot for the Seminoles in that game was a 60-yard field goal by Gary Cismesia, the longest in FSU history. This picture shows the Seminoles deep in their own territory with a long way to go for a touchdown. (Zeng8r, Wikimedia Commons.)

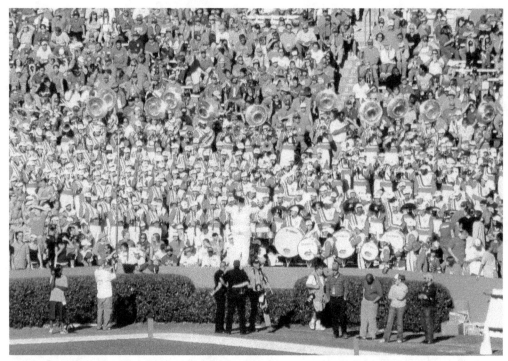

The Fightin' Gator Marching Band, also known as the Pride of the Sunshine, also performs at other functions like parades and special events. The band played in England for the 2012 summer Olympics. (Jillian Cain, Shutterstock.com.)

Local Gator Robert Cade (1927–2007) was one of the inventors of Gatorade. He and his team invented the drink when they found out that football players suffered from extreme dehydration during games because of the state's high temperatures and humidity. Royalties from the sale of the sports drink have benefited the university and many of its students. (Jeff Taylor.)

When the No. 2 Gators (11-1) went to Tallahassee in 2008, the Seminole mascots, Chief Osceola and his horse Renegade, rode to midfield and planted a burning spear in the turf. Originating in 1978, the mascots have the approval of the Seminole Tribe of Florida. FSU athletes call themselves "Seminoles" in admiration of the only Native American tribe never conquered by the US government. (cholder68, Wikimedia Commons.)

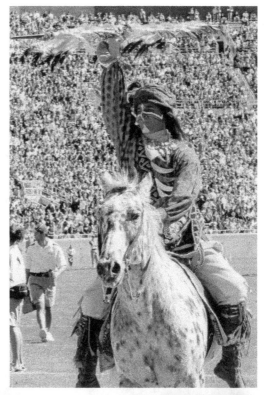

The Gators easily beat their cross-state rivals 45-15 in 2008, extending coach Urban Meyer's winning streak against the Seminoles (8-4) to four. It also marked the sixth straight road win for the Gators that year. Coach Urban Meyer and quarterback Tim Tebow (No. 15) formed a close friendship that produced remarkable results on and off the field. (Harrison R. Diamond.)

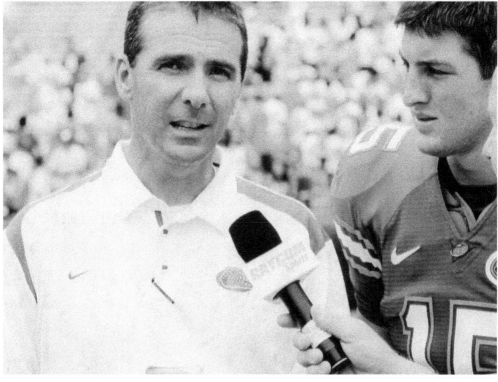

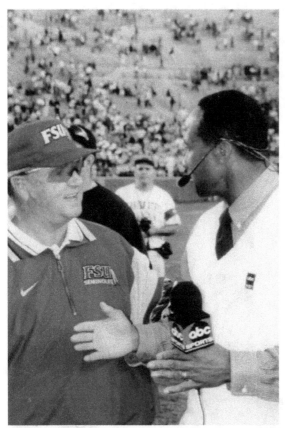

Both teams were so good that they were frequently on television. Sportscasters like ABC's Lynn Swann usually enjoyed interviewing FSU head coach Bobby Bowden because of the frankness and good humor that the coach usually had toward such interviewers. This particular interview took place in 1997, but such interviews were frequent in Bowden's career. (State Archives of Florida, Florida Memory.)

In 2008, the Gators won the SEC East, then beat top-ranked Alabama in the SEC championship game, and then defeated Oklahoma in the BCS national championship game to finish No. 1 in the AP Poll and the Coaches' Poll. It was their third national title, the others being in 1996 and 2006. President Obama welcomed them to the White House in April 2009. (Wikimedia Commons.)

UF head coach Urban Meyer led the Gators to be honored by the president at the White House. Whenever the Gators or Seminoles won the national championship, they were later honored at the White House. The Gators began the 2009 season voted No. 1 in several polls and had only the second undefeated regular season in the program's history. (Wikimedia Commons.)

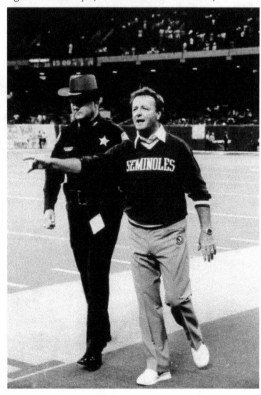

A record 90,907 fans attended the 2009 game in Gainesville, which the Gators won 37-10. It marked the 37th and last match that Bobby Bowden, shown here earlier in his career, coached before retiring that season. His record against the Gators was a disappointing 17-18-1, but it also spanned seven different Gator coaches. (State Archives of Florida, Florida Memory, photographer Deborah Thomas.)

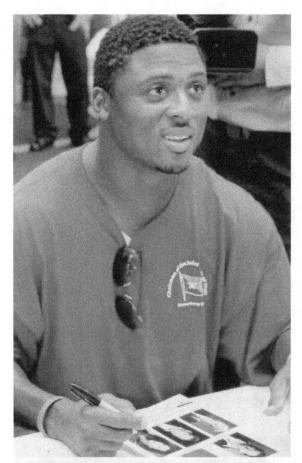

One of Coach Bowden's many great players was Warrick Dunn, an All-American at FSU for three years (1994, 1995, and 1996) and a player in the NFL for 12 seasons, seen here signing autographs in 2009 on the aircraft carrier USS *Ronald Reagan*. (Photograph by MC1 Chad J. McNeeley, US Navy.)

The official marching band of FSU is called the World Renowned Marching Chiefs. They perform at all home football games and at several away games each year. The group has over 470 members, called Chiefs, and come from many academic departments at the school. This picture shows them performing at halftime during a Seminole game. (P. Spisak.)

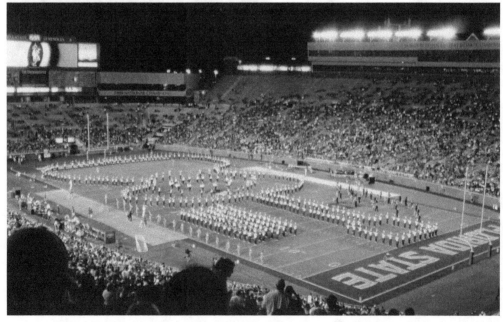

2 0 1 0 S

In 2010, in what was FSU head coach Jimbo Fisher's first game against the Gators, the Seminoles won convincingly, 31-7. That was also UF head coach Urban Meyer's last such rivalry game and his only loss to FSU in six tries. Jimbo Fisher and Virginia Tech head coach Frank Beamer are pictured here at the ACC championship game. (Daniel Lin.)

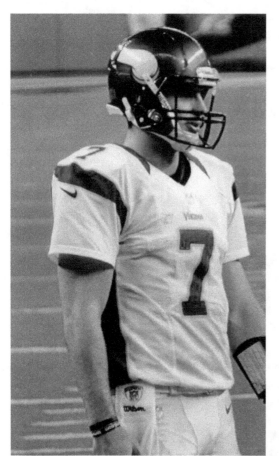

One of the stars for the Seminoles during the 2010 season was quarterback Christian Ponder, seen here in his Minnesota Vikings uniform when he played in the NFL (2011–2015). He and his wife, the former Samantha Steele, named their first child Bowden Saint-Claire Ponder, after his favorite FSU coach, Bobby Bowden. (Kevind810, Wikimedia Commons.)

The pregame festivities at Doak Campbell Stadium feature the Marching Chiefs. Banners for the 1993 and 1999 national championships are visible on the far stadium wall. To further enhance the close ties between the university and the Seminole Tribe, the tribe helped design a course for FSU students called the "History of the Seminoles and Southeastern Tribes," which focuses on Seminole history and traditions. (Ayzmo, Wikimedia Commons.)

The Gators had a new head coach, William "Will" Muschamp, a defensive specialist, but he could not beat the Seminoles in 2011. In fact, the Seminoles extended their winning streak over the Gators by beating them 21-7 that year despite gaining fewer than 100 yards in the defensive battle; it was the first Seminole victory at Ben Hill Griffin Stadium since 2003. (Jordon Kalilich.)

Playing the Seminoles in Doak Campbell Stadium usually entailed much well-executed pageantry, as seen here. That season, the Seminoles beat Notre Dame in the Florida Citrus Bowl 18-14, and finished the season at a respectable 9-4. The Gators beat the Ohio State Buckeyes in the Taxslayer.com Gator Bowl 24-17, and finished the season at a disappointing 7-6. (Qpzmal13, Wikimedia Commons.)

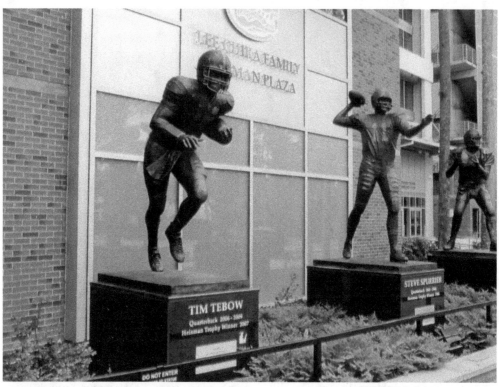

Back in Gainesville in April 2011, officials installed life-size bronze statues of Heisman Trophy winners Steve Spurrier, Danny Wuerffel, and Tim Tebow outside the west side of the stadium along Gale Lemerand Drive. The fact that both schools had three Heisman Trophy winners showed how similar the football programs were. (Kevin McCarthy.)

The official mascots of UF's athletic teams are Albert E. Gator and Alberta Gator. The anthropomorphic representations of American alligators are appropriate since the state has so many gators in its lakes and rivers. In fact, the American alligator is the official Florida state reptile. Albert was first used in 1970, while Alberta made her first appearance in 1984. (Fuzzy510, Wikimedia Commons.)

The 2012 game in Tallahassee did not go well for the Seminoles, who turned the ball over five times. The Gators scored 24 straight points in the fourth quarter to win the game 37-26. Before some games, FSU honors the military by having them receive acknowledgement from the fans, as seen here in the 2010s. (Wikimedia Commons.)

The Seminoles beat Georgia Tech in the ACC championship game that year, 21-15. From 1992 through 2015, the Seminoles won or shared the ACC championship 15 times, as evidenced by FSU's trophy case. The Seminoles finished the 2012 season with an excellent record of 12-2, while the Gators finished the season with a fine record of 11-2. (UkrNole 485, Wikimedia Commons.)

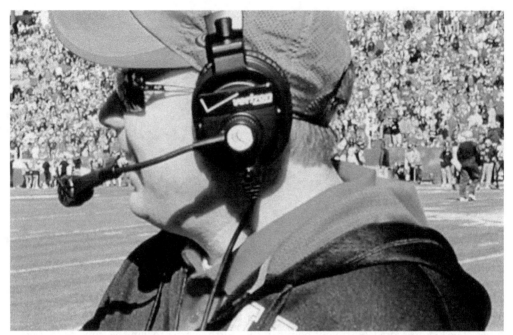

As has happened many times over the years, one of the assistant coaches on one of the two teams became a head coach elsewhere. After the 2012 season, FSU defensive coordinator Mark Stoops left to become the head football coach at Kentucky. (Photograph by S.Sgt. Scott Raymond, US Army National Guard.)

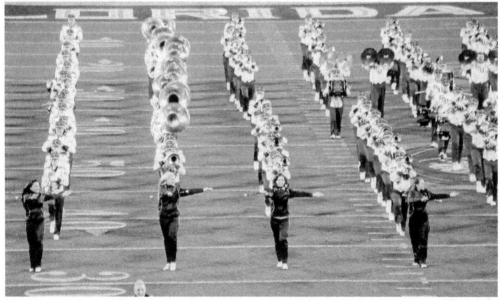

The 2012 loss brought Florida State's all-time record against the Gators to 21-34-2 and 11-13-1 at Doak Campbell Stadium. A highlight of each home game or championship game and some away games was the appearance of the Marching Chiefs. A favorite tradition of the band is to sing "The Hymn to the Garnet and Gold" at the end of every game. (Jayron32, Wikimedia Commons.)

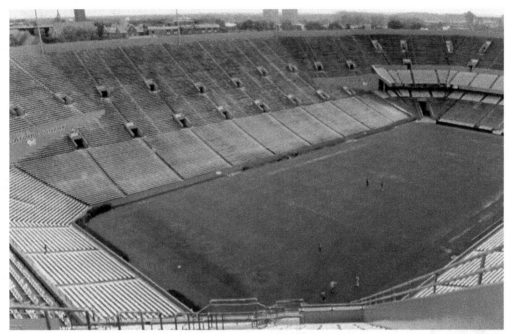

The Seminoles were 11-0 when they faced the struggling 4-7 Gators in Gainesville in 2013. The Seminoles easily won 37-7, enabling them to finish the regular season undefeated. FSU then won against Duke in the ACC championship and then beat Auburn in the final BCS national championship game for their third consensus national championship, their first since 1999. (Nolephin, Wikimedia Commons.)

Right after the conclusion of that very successful season, coach Jimbo Fisher joined in celebrating the Seminoles winning the national championship. The Seminoles won their 17th conference title and third national championship, earning the Grantland Rice Award, the MacArthur Trophy, the Associated Press Trophy, and the AFCA National Championship Trophy. (Nolephin, Wikimedia Commons.)

The Seminoles were led by their highly skilled quarterback Jameis Winston, who won the Heisman Trophy in 2013 and thus joined two other Seminole quarterbacks who won the nation's highest award for a college football player, Charlie Ward in 1993 and Chris Weinke in 2000. That year, the Seminoles had a school-record 14 wins, achieving their third undefeated season. (David July.)

The Seminoles had 456 yards of offense to the Gators' 193 total yards. Quarterback Winston completed 19 of 31 passes for 327 yards and three touchdowns in the win. FSU that year set the record for most draft picks in a three-year span, 29. Devonta Freeman, pictured here in 2014, rushed for over 1,000 yards on the ground; he was the first Seminole to do so since Warrick Dunn in 1996. (Thomson200, Wikimedia Commons.)

When the Gators went to Tallahassee in 2014 to face the undefeated and No. 1 Seminoles at the modernized Doak Campbell Stadium, UF had already fired its head coach Will Muschamp but allowed him to coach the season's final games. Doak Campbell Stadium, the scene of fireworks from time to time, was very inhospitable for opponents, including the Gators. (Melizabethi123, Wikimedia Commons.)

Despite four interceptions, the Seminoles won 24-19 in 2014 and finished with a superb 13-1 record and a No. 5 ranking in one poll, whereas the Gators finished with a poor 7-5 record. Muschamp's four seasons as Gator head coach saw a poor record of 28-21. FSU quarterback Winston addressed the House of Representatives during "FSU Day" in April 2014. (State Archives of Florida, Florida Memory, photographer Bill Cotterell.)

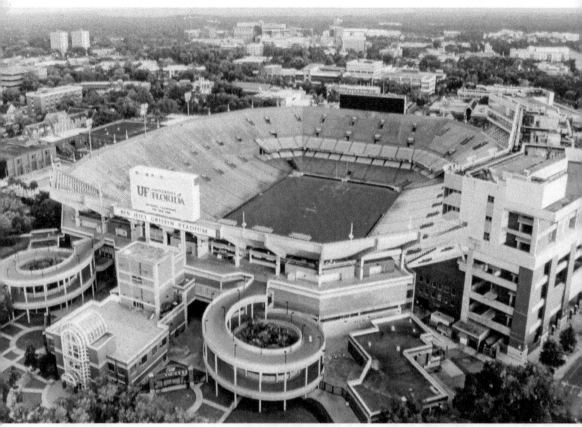

Ben Hill Griffin Stadium was the scene of the 2015 game, which FSU won 27-2. The No. 12 Gators had a new coach, Jim McElwain, who had been head coach at Colorado State University (2012–2014), where he had achieved great success. He was named SEC Coach of the Year in 2015. (Pablo Corredor.)

The Gators finished the 2015 season with a disappointing 10-4 record, while the Seminoles had a 10-3 record. Both teams had strong recruiting classes in early 2016 and figured to be back in the hunt for another national championship or at least a high end-of-season ranking. Both campuses, including FSU's plaza in front of the Westcott Building, hoped to see many more championship celebrations. (Patrick Landy.)

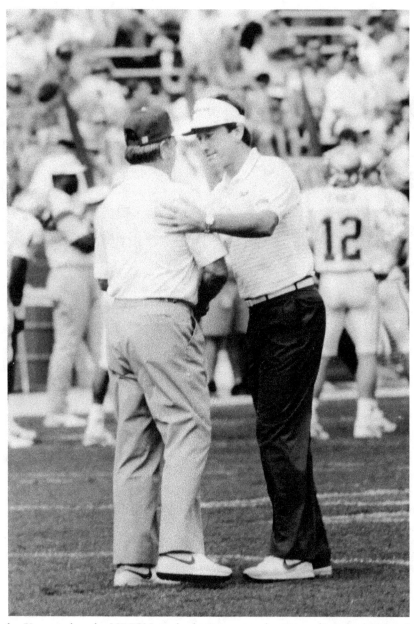

During the 58 years that the UF-FSU rivalry has gone on, the Gators have had 13 head coaches: Bob Woodruff, Ray Graves, Doug Dickey, Charley Pell, Galen Hall, Gary Darnell, Steve Spurrier, Ron Zook, Charlie Strong, Urban Meyer, Will Muschamp, D.J. Durkin, and Jim McElwain. The Seminoles have had seven head coaches: Tom Nugent, Perry Moss, Bill Peterson, Larry Jones, Darrell Mudra, Bobby Bowden, and Jimbo Fisher. The teams have played each other twice in one season in two of those 58 years. The Gators lead the series with FSU, 34-24-2. The series is tied 5-5 over the past 10 meetings and 10-10 over the past 20 meetings. Chances are that the rivalry will continue to be one for the ages. Fans can only hope that the UF-FSU competition will rival that of coaches Bowden and Spurrier. (UF Information Services, Buddy Long.)

UF–FSU
SERIES RECORD

DATE, WINNER, SCORE, SITE

Nov. 22, 1958, UF, 21–7, Gainesville
Nov. 21, 1959, UF, 18-8, Gainesville

Sept. 24, 1960, UF, 3-0, Gainesville
Sept. 30, 1961, Tie, 3-3, Gainesville
Nov. 17, 1962, UF, 20-7, Gainesville
Nov. 30, 1963, UF, 7-0, Gainesville
Nov. 30, 1964, FSU, 16-7, Tallahassee
Nov. 27, 1965, UF, 30-17, Gainesville
Oct. 8, 1966, UF, 22-19, Tallahassee
Nov. 25, 1967, FSU, 21-16, Gainesville
Sept. 28, 1968, UF, 9-3, Tallahassee
Oct. 4, 1969, UF, 21-6, Gainesville

Oct. 10, 1970, UF, 38-27, Tallahassee
Oct. 16, 1971, UF, 17-15, Gainesville
Oct. 7, 1972, UF, 42-13, Tallahassee
Dec. 1, 1973, UF, 49-0, Gainesville
Oct. 19, 1974, UF, 24-14, Tallahassee
Oct. 18, 1975, UF, 34-8, Gainesville
Oct. 16, 1976, UF, 33-26, Tallahassee
Dec. 3, 1977, FSU, 37-9, Gainesville
Nov. 25, 1978, FSU, 38-21, Tallahassee
Nov. 24, 1979, FSU, 27-16, Gainesville

Dec. 6, 1980, FSU, 17-13, Tallahassee
Nov. 28, 1981, UF, 35-3, Gainesville
Dec. 4, 1982, UF, 13-10, Tallahassee
Dec. 3, 1983, UF, 53-14, Gainesville
Dec. 1, 1984, UF, 27-17, Tallahassee
Nov. 30, 1985, UF, 38-14, Gainesville
Nov. 29, 1986, UF, 17-13, Tallahassee
Nov. 28, 1987, FSU, 28-14, Gainesville
Nov. 26, 1988, FSU, 52-17, Tallahassee
Dec. 2, 1989, FSU, 24-17, Gainesville

Dec. 1, 1990, FSU, 45-30, Tallahassee
Nov. 30, 1991, UF, 14-9, Gainesville
Nov. 28, 1992, FSU, 45-24,, Tallahassee
Nov. 27, 1993, FSU, 33-21, Gainesville
Nov. 26, 1994, Tie, 31-31, Tallahassee
Jan. 2, 1995, FSU, 23-17, New Orleans
Nov. 25, 1995, UF, 35-24, Gainesville
Nov. 28, 1996, FSU, 24-21, Tallahassee
Jan. 2, 1997, UF, 52-20, New Orleans
Nov. 22, 1997, UF, 32-29, Gainesville
Nov. 21, 1998, FSU, 23-12, Tallahassee
Nov. 20, 1999, FSU, 30-23, Gainesville

Nov 18, 2000, FSU, 30-7, Tallahassee
Nov. 17, 2001, UF, 37-13, Gainesville
Nov. 30, 2002, FSU, 31-14, Tallahassee
Nov. 29, 2003, FSU, 38-34, Gainesville
Nov. 20, 2004, UF, 20-13, Tallahassee
Nov. 26, 2005, UF, 34-7, Gainesville
Nov. 25, 2006, UF, 21-14, Tallahassee
Nov. 24, 2007, UF, 45-12, Gainesville
Nov. 29, 2008, UF, 45-15, Tallahassee
Nov. 28, 2009, UF, 37-10, Gainesville

Nov. 27, 2010, FSU, 31-7, Tallahassee
Nov. 26, 2011, FSU, 21-7, Gainesville
Nov. 24, 2012, UF, 37-26, Tallahassee
Nov. 30, 2013, FSU, 37-7, Gainesville
Nov. 29, 2014, FSU, 24-19, Tallahassee
Nov. 28, 2015, FSU, 27-2, Gainesville

Total meetings 60
Florida leads, 34-24-2

Visit us at
arcadiapublishing.com